Eduardo Paolozzi

UWE M. SCHNEEDE

11 COLOUR PLATES, 53 MONOCHROME PLATES

THAMES AND HUDSON · LONDON

Translated from German by W. Woodson Hand

General Editor: Werner Spies

First published in Great Britain in 1971 by
Thames and Hudson Ltd, London

© 1970 by Verlag Gerd Hatje, Stuttgart

Printed in West Germany

ISBN 0 500 22008 5

When Eduardo Paolozzi took up a guest lectureship at the University of California, Berkeley, in 1968, his curiosity about the strange, new environment was in no way directed towards museums and galleries. Nor was he interested in the fascinating landscape. Instead, he visited Disneyland, the Paramount Studios in Hollywood, the computer centre at the University of California, the waxworks in San Francisco and Los Angeles, the particle accelerator at Stanford and the Douglas Aircraft Company in Santa Monica.[1] Likewise, during his guest lectureship at the Hochschule für bildende Künste in Hamburg from 1960 to 1962, he did not discover the German romantics whose paintings are hanging in the Kunsthalle; instead he visited scrap-metal lots and ship salvage yards.

In the winter of 1952/53, when several artists (including Paolozzi), architects, photographers and art critics formed the Independent Group in London to discuss artistic techniques, the subjects were not lithography and concrete sculpture but rather the mass media of modern civilization: film, advertising, industrial design, science fiction, comic strips, pop music. The architectural historian Reyner Banham reported on car models and sex symbolism; the painter Richard Hamilton on consumer products; the composer Frank Cordell on pop music; the art critic Lawrence Alloway on the relationship between science fiction and the pictorial arts; the art critic Toni del Renzio on fashion. At the first meeting of the Independent Group in 1952, Eduardo Paolozzi presented a series of slides with motifs from commercial art, advertisements, horror films, comic strips and magazines.[2] "What is needed," wrote Richard Hamilton in 1956, "is not a definition of meaningful imagery but the development of our perceptive potentialities to accept and utilize the continual enrichment of visual material."[3]

In 1953, the Independent Group presented an exhibition called *Parallel of Life and Art* at the Institute of Contemporary Arts in London. Paolozzi, the photographer Nigel Henderson and the architects Alison and Peter Smithson were major participants in this exhibition. A text on the exhibition discussed the implications of the mass media in this light: "Technical inventions such as the photographic enlargement, aerial photography and the high-speed flash have given us new tools with which to expand our field of

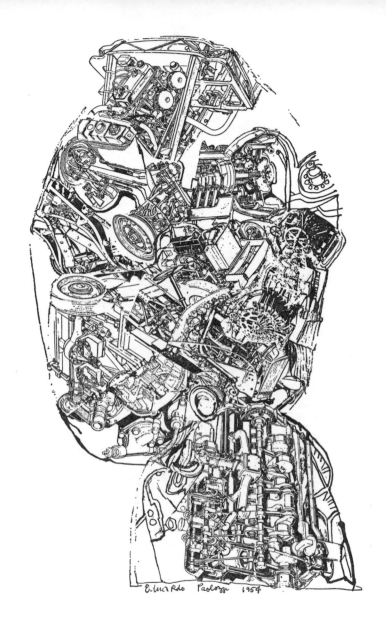

Automobile Head, 1954. Screenprint, 22 × 14″
Standing Figure, 1958. Screenprint, 20 × 9 ▷

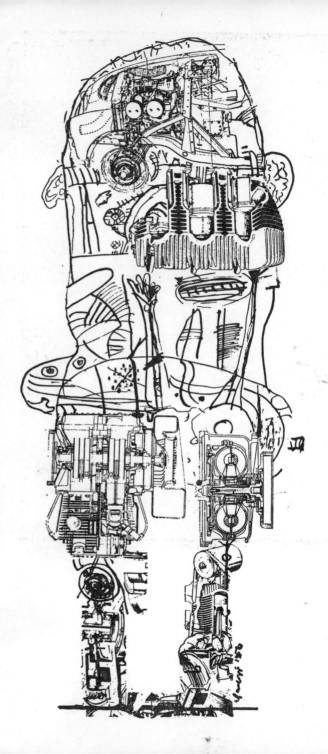

vision beyond the limits imposed on previous generations. Their products feed our newspapers, our periodicals and our films, being continually before our eyes; thus we have become familiar with material and aspects of material hitherto inaccessible."[4]

The exhibition *Man, Machine and Motion* followed in 1955, and in 1956 *This is Tomorrow* (Whitechapel Gallery) featured picture blowups of Marilyn Monroe and beer bottles, long before there was any talk of Pop Art. Increased interest in an expanded aesthetic found expression in these pioneering ventures, which drew as much from traditional arts as from the media of mass communication, from subcultural pictorial and literary products and from technology, and did so in the sense of a "popular culture", a "folk art" of civilization. It is not without recalling the first attempts of the Dadaists that one expands the concept of "culture", that one tries to break down the traditional antagonism between culture and civilization and thereby achieves an anticipation of Pop Art and the contemporaneously developing idea of an integral pop culture. The activities of the Independent Group were remarkably early; during the middle 1950s, the art market gave the impression that the future would lie more in abstract easel painting which, as an aesthetic object, dissociates itself from reality and perpetuates the antithesis to subculture.

Paolozzi played an integral role in this proto-pop movement. From the outset his interests lay in the extremes of technology and subculture or, as he says himself, in technology and *Kitsch*. "Being brought up in a city," wrote Paolozzi in 1957, "I always read pulp magazines, including stories of air battles and science fiction. I think that machines and fantasy go together."[5] In a lecture at the Institute of Contemporary Arts in London in 1958, Paolozzi declared: "It is conceivable that in 1958 a higher order of imagination exists in a science-fiction pulp production in the outskirts of Los Angeles than in the illustrated magazines of today... Does the modern artist take this sufficiently into consideration?"[6]

Mass culture is Paolozzi's point of departure; hence the fundamental difference from Henry Moore who, even in the 'fifties, was considered the patriarch of modern British sculpture. Paolozzi finds his bearings in a hate-love relationship to "grotesque America". He

6

Wittgenstein in New York
Screenprint from: *As Is When*, 1965, 32 × 22″

Wittgenstein the Soldier
Screenprint from: *As Is When*, 1965, 32 × 22″

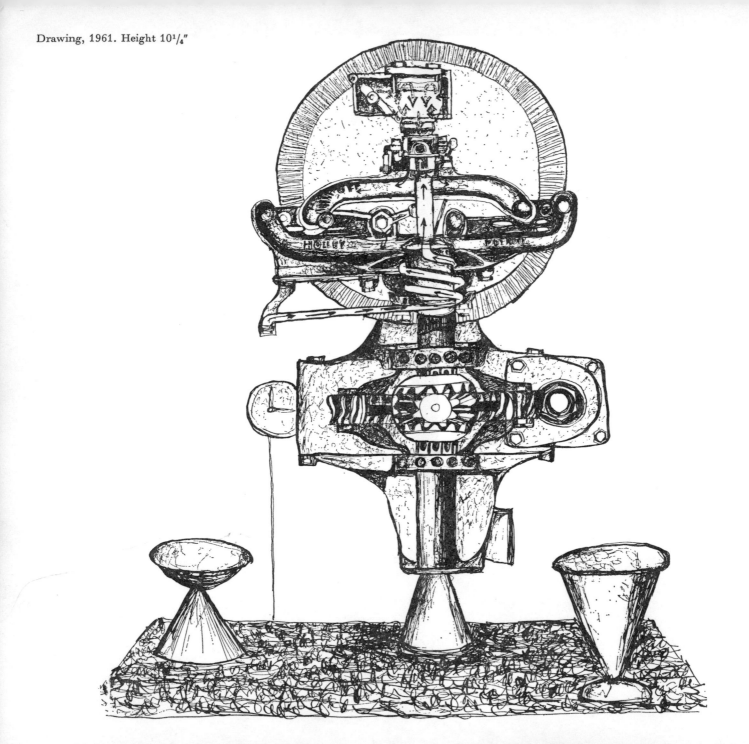

Drawing, 1961. Height 10¼"

does not start with the artistic ideas of Henry Moore, Alexander Archipenko or David Smith, but rather from the encounter with Mickey Mouse and the knowledge of this character's tremendous popularity, from the encounter with a Harley-Davidson, with Frankenstein and the computer, with swimming-pool ads, Batman and the technical illustrations in *Scientific American*. The whole world of pictures, especially mechanically-reproduced pictures, the whole inventory of magazine stereotypes, is an unlimited source for his artistic activities. They are perceived as extraordinarily influential media which, in quantitative effect alone, far surpass all previous pictorial means, and which also affect the creative artist: "The evolution of the cinema monster from Méliès[7] onwards is a necessary study for the fabricator of idols or gods containing elements which press in the direction of the victims' nerve-senses."[8]

Characteristic of the activities of the London Independent Group is the fact that the new ideas found expression more in the process of opinion formation *via* discussions and exhibitions than in works of art. An exception is Richard Hamilton's now famous collage, *Just what is it that makes to-day's homes so different, so appealing?* (reproduced in the exhibition catalogue for *This is Tomorrow*) in which the concept "Pop" (short for "popular culture") emerges for the first time. Hamilton's collage alludes to the whole gamut of inspirational sources: to consumer products, technical commodities, porno magazines, comic strips, advertising—to the range of "popular images" which Paolozzi also feels at home with and which pervades his activities, his life and his works.

Up to now, there is probably only one pictorial-artistic possibility for visualizing the multiplicity of such images without exposing them to an *a priori* mingling or slurring: the collage. "A collage", writes Franz Mon, "unites in one composition elements which stem from the environment of modern civilization and which carry the traces of fashioning, and thus are socially mediated... Collage transposes existing, mediated reality into a newly constituted art-world. There is nothing real that could not become an element of a collage."[9] Allan Kaprow is of the opinion, and rightly so, that the collage "was the first to stimulate a certain kind of thinking, the 'impure', that is, anti-classical and anti-traditional; ...a kind of

thinking which is concerned with accepting what is there."[10] The producer selects the fragments of reality; the viewer can draw his own conclusions.

This approach particularly characterizes Paolozzi's non-plastic collage works: his books, the graphic sheets and the film *The History of Nothing* (1962). Combinations of disorganized wheels and human figures—with clear relationship to his own contemporary sculptures—comprise the prints and drawings of the 'fifties; the elements of the later collages constitute a much wider multiplicity of motifs. The first photo-lithos, based on the collage principle, were done in 1961 in Hamburg; starting in 1962 Paolozzi created increasing numbers of silk screens incorporating disparate illustrative materials from scientific works, catalogues, films, magazines, comic books and advertisements. "The morphology of his images is nearly as diverse as the contents of an encyclopedia."[11]

In *Metafisikal Translations* (1960) and *Kex* (1966) readers of the books are presented with words and pictures, which they then have to place in combination.[12] (Paolozzi gave the manuscript materials for *Kex* to Richard Hamilton who compiled them according to his own ideas.) The *Moonstrips Empire News* (1967) consists of a box and its materials in seemingly haphazard arrangement: texts and pictures on a hundred uniform-sized sheets which the viewer can lay out or arrange to suit his own intentions.[13] No one arrangement is more conclusive or significant than another; unlike puzzle games, for example, the collage principle is not bound to one solution. Also, the strictly observed juxtaposition of such disparate images confronted with constructivist colour elements—allusions to Mondrian and Noland—is a distinctive feature of the silk-screen series *As Is When* (1965), *Universal Electronic Vacuum* (1967), *General Dynamic F. U. N.* (1968) and—more clearly, if not more precisely —*Zero Energy Experimental Pile* (1970). Paolozzi's characteristic transformation of all the original objects by print-technique transference, however, yields a coalescence which is clearly distinguished from a Dadaist collage, in which the initial elements remain what they are.[14]

The silk-screen principle also holds in the randomly ordered and filmed photo-collages entitled *The History of Nothing* (1962). Here

again, the plurality of materials has something in common; namely, the origin from trivial spheres—the reflection of the civilized world based on stereotypes from the world of magazines, especially picture magazines, and compiled into a *résumé*, the evaluation of which is left up to the viewer. The viewer must perform the act of recognition. This demands "increased activity from the viewer who no longer finds himself confronted with a work of art in finished form, but rather must supplement by association what is no longer presented. Thus, in the transforming character of works of art, the changes of reality and the altered situation finally meet and reveal themselves in the manner in which the artist relates himself to it."[15]

The origins of Paolozzi's interest in collages lie with the Dadaists. During his stay in Paris at the end of the 'forties, he became acquainted with Giacometti and Brancusi as well as Tristan Tzara. In the collections of Mary Reynolds and Tristan Tzara,[16] he ran across an abundance of Dadaist works. He was particularly impressed with the drawings and collages of Francis Picabia and Max Ernst from the period between 1915 and 1920. There he found what he was to utilize later: semi-automatic production processes, processes with prefabricated elements; inclusion of banal fragments of reality; close connections with technical drawings and mechanical forms; the first signs of a liberation from traditionalized concepts of beauty; preservation of inconsistencies; extension of the artistic interest into non-artistic areas. These stimuli from the Dadaists find expression everywhere in Paolozzi's work. While the accomplishments of the Dadaists were generally still ignored in Europe, they stirred Paolozzi to an antithetical concept of artistic purpose which was unfamiliar at that time.

The Dadaist rejection of the artist mystique is particularly important for Paolozzi and his position. The traditional world of art which has become peripheral is not his *milieu*, but rather reality itself, the environment with the image which it reproduces of itself. The Dadaist predilection for ready-mades and *objets trouvés* becomes apparent when Paolozzi writes: "The history of man can be written with objects." And further on he makes particular reference to sculpture: "A continual diary of opposites. Nature as fabricator,

man as engineer."[17] Thus, man is not the autonomous creator starting from nothing, but rather the designer working with materials available to him from the environment, working with artefacts: combinative association with already-invented products, rather than the invention of new forms. The result must, of necessity, signify or suggest a reflection of the transformed initial products. Paolozzi said later he wanted to use the mass media, that is, industrial production, reproduction techniques, "popular images", for his work— but in an individual manner. This component of individuality modifies the stereotype of the artist as an engineer but does not destroy it.

That the discussions and exhibitions in London, at least in the early 'fifties, had little to do with the artistic production of the participants, has already been mentioned. The development of ideas in London—as contrasted with the faster moving American Pop Art—proceeded separately from the realization of them. Paolozzi's Paris years (1947–49) provided impulses for later realization, just as did the Independent Group in London. Nevertheless, pieces such as *Paris Bird* (26) of 1948 and *Table Sculpture* (27) of 1948/49, which appeared in the 'forties, established Paolozzi as a sculptor.[18] The artist's own invention of form cannot be denied in both works; yet they are related to the then current progressive ideas of sculpture as a biomorphic sign in space. *Paris Bird* is no doubt to be seen in the context of David Smith's early works, but it almost anticipates the clear hardness and simplicity of Smith's later development. Paolozzi here employs the wheel form which was later to become such a frequent and important element in his work—and in a relatively archaic variation at that.

Paolozzi struck upon a highly interesting iconographic theme in *Table Sculpture* (1948/49; 27).[19] Although formally oriented towards Giacometti's surrealistic sculpture of the 'thirties and possibly directly related to his *Table surréaliste* of 1933, this work does not allude to the contemporaneous autonomous-abstract sculpture of Moorean origin; rather it forms an initial step towards a sculpture near to reality without illustrative character. The individual, plastic modelling is characteristic. This idiosyncratic impulse becomes increasingly weaker in the later works. The motif is captivating

10

Donald Duck meets Mondrian
Screenprint from: *Moonstrips Empire News*, 1967, 15 × 10″

Secrets of the Internal Combustion Engine
Screenprint from: *Moonstrips Empire News*, 1967, 15 × 10″

in so far as it falls within a whole series of sculptures in which a table forms the basis for an arrangement of elements which characterize the sculptor's repertory of forms at various stages. The result is a sort of "metasculpture": a statement by the sculptor about his work and his creative media. In addition to the Giacometti piece, this motif-series includes Max Ernst's *Table mise* (1944), Jean Ipoustéguy's *Roger et le peuple des morts* (1959/62), Daniel Spoerri's *Tableaux-pièges* (since 1960), Horst Antes' *Tisch des Geometers* (1967) and, not least, *Mekanik's Bench* (1963; 50) by Paolozzi himself.[20]

Ten years separate these works of the late 'forties from the second sculptural phase. What did Paolozzi do in the meantime? He worked primarily with the Independent Group and the Institute of Contemporary Arts. He appeared to be absorbing rather than creating. His artistic production was reduced to experiments and group projects. Designs for textiles and wallpapers, a sculpture and a fountain for the Festival of Britain (1951), and three fountains for a park in Hamburg (1953) comprised his output.

It was not until around 1956 that sculptural activity regained importance—he now concentrated on it. He produced bronzes: animals, heads, human shapes. Some years previously Paolozzi had tried to suffuse their surfaces with prefabricated, perishable consumer goods. But this process—a legacy from the Dadaists—did not satisfy him for practical reasons. The inserted elements broke out; the sculpture lost its epidermis. In *Head* (28), *Icarus II* (30, left), *St. Sebastian I* (29) – all from 1957 –, *Monkey Man* (30, right), *Chinese Dog II* (31), *Japanese War God* (34) – all from 1958 – and *St. Sebastian III* (35) and *His Majesty the Wheel* (32/33) – both 1958/59 – the procedure is different: *objets trouvés* emboss the bronze surface of the sculpture like stamped imprints.[21]

The technical process for producing these sculptures is variable. Paolozzi presses the most diverse items into soft clay to derive a negative form; a wax casting provides a positive. Or the *objets trouvés* are mortised with clay; a negative plaster mould again yields a positive in the wax casting. The wax forms are stamped with machine parts—yielding a matrix of positive and negative forms—as well as fashioned and modelled with various tools. The bronze casting resulting from the *cire-perdue* process (which guarantees uniqueness), forms the multifarious surface of the sculpture.

Paolozzi has enumerated some of the *objets trouvés* which are employed in this process: "Dismembered lock, toy frog, rubber dragon, toy camera, assorted wheels and electrical parts. Clock parts, broken comb, bent fork...gramophone parts, model automobiles." For Paolozzi these pieces illustrate "sheets of an alphabet of elements awaiting assembly... grammar of forms ... dictionary of design elements."[22]

The transformation of *objets trouvés* is an essential step in the procedure: "I really set out in my sculpture to transform the *objets trouvés* that I use to such an extent that they are no longer immediately recognizable, having become thoroughly assimilated to my own particular dream world rather than to an ambiguous world of common optical illusion."[23]—"In the finished casting, the original *objets trouvés* are no longer present at all, as they are in the Dada and Surrealist compositions of this kind. They survive in my sculpture only as ghosts of forms that still haunt the bronze, in details of its surface or its actual structure."[24]—"I suppose I am interested, above all, in investigating the golden ability of the artist to achieve a metamorphosis of quite ordinary things into something wonderful and extraordinary that is neither nonsensical nor morally edifying."[25]

This procedure yields neither concrete nor abstract sculpture. The starting point is the general constellation of a head with a throat, an animal body with four legs or a human body (trunk and head) with two legs. Beyond this general constellation nothing is preserved; all details are subject to modification *via* the combined procedure of new design, plastic modulation and stamping with machine parts. A new shape is developed which has no accidental aspects, but nevertheless stands apart from all that is familiar; it is clearly related to humans and the technical world without itself being either man or machine.

Dialectical principles underlie these sculptures in terms of both technique and content. On the one hand, Paolozzi employs a multiplicity of materials as his starting point while, on the other,

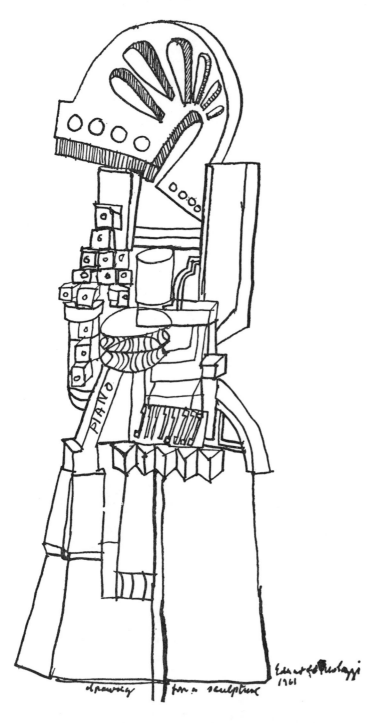

drawing for a sculpture
Eduardo Paolozzi
1961

he homogenizes these disparate materials by means of bronze casting. Hence the result is neither a Dadaist collage of finished parts nor a thoroughly kneaded, uniform figure; nor is it the unrestrained dissolution of the plastic structure in the sense of the *informal*. The collage determines the process, but the result is a homogeneous entity which still manifests the process. Paolozzi's later development draws less upon the collage principle than upon the shape it has helped to develop.

The dialectic of content becomes clear when one confronts the titles of these works with their physical appearance: *Japanese War God, Jason, Greek Hero, Icarus, St. Sebastian.* Allusions are made to heroes and brave men, the figures presented are tattered, their surfaces torn—they have been created with the help of civilization's refuse. The powerful, statuesque shapes are actually ruins with a possible trace of previous greatness, but still only the products of destruction. These sculptures appear to be relics of a bygone world; remnants of something which—in the age of mass destruction—continues to exist only as a legend in grandiloquent words like "fantastic, magical and tormenting phenomena" (Paolozzi): personal symbols for the discrepancy between a historically-matured selfconsciousness and the actual collapse of exemplary humanity or even godliness. What is significant here is that again, as the product of destruction, a shape arises which is not free of monumentality. The tension of these sculptures lies in their paradoxes.

Little wonder that these new shapes, standing at the intersection of various references, are occasionally associated with the monsters of horror films and science fiction, monsters whose superhuman abilities (given new standards of mass culture) have reduced the exploits of the ancient heroes and gods to cheap melodrama. For Paolozzi, robots also fall within the associational reach of these plastic monuments. But these associations, in turn, only unfold by way of the dialectical principle: the robots are already burned out

Drawing for a sculpture, 1961. Height 9¹/₄″

the minute they come to light as the end-product of the sculptor's activity. Destruction and construction are congruent in these sculptures which embody a greater span than all of Paolozzi's later works; he does not resume this approach until 1969/70.

A stylistic aspect has still to be mentioned, namely, Paolozzi's relationship to the *art brut* of Dubuffet. During Paolozzi's Paris sojourn, he became acquainted with Dubuffet's works and his *art brut* collection. He shares with Dubuffet a predilection for ugly materials and crude treatment; Dubuffet's paintings and sculptures from the first half of the 'fifties have much in common with Paolozzi's sculptures in terms of shape and surface finishing. This is especially true of *Icarus II* (1957; 30, left) and *Monkey Man* (1958; 30, right)[26] which remind one of the *Ragged One*, a clinker sculpture by Dubuffet from the year 1954.[27]

Japanese War God (1958; 34) and *His Majesty the Wheel* (1958 to 59; 32/33) offer, almost contemporaneously, an increasing reification through the clarity of the object-stamps that condition the surface. Beneath them, the plastic nucleus disappears almost completely. Motifs begin to appear which will play a greater role later on: quadrangular or round tower-forms (to be identified here as "legs"), a crowning wheelform and—in *St. Sebastian III* (35)—a system of little boxes which, like the sculpture in general, has an architectonic character. The apertures in *St. Sebastian III* are not—as is the case with Henry Moore—modulated, activated hollow space, but rather gaps in the structural system with more of a destructive than constructive significance: something appears to be missing, to have fallen out. The process of association again transfers from the ruin to the former perfect shape, out of which the ruin emerged. A growing clarity in structure becomes manifest in these pieces, and this can be seen in the new works that were done just a few years later: "A certain kind of accuracy became necessary and the need to include irony."[28]

During his guest lectureship in Hamburg (1960–62), Paolozzi discovered ship salvage yards and scrap-metal lots, where the discarded iron only occasionally betrays its previous function. Paolozzi reacted to it much the same as David Smith did when he was in Spoleto to carry out two commissions and came upon an abundance of iron scrap (and did 26 sculptures): the stimulus of the material provided the impetus for completely new sculptures. David Smith designed his constructivist *Voltri-Boltons* and *Cubi;* Paolozzi developed his austerely structured "towers". In both cases the clear structure appears removed from the accidental agglomeration of scrap piles; it seems to establish a new order by means of them.

At the same time, Paolozzi employed new materials: gun metal and aluminium. While *Tyrannical Tower* (1961; 36) was cast in bronze and imprinted with the usual stamps at least around the pedestal, this same basic form in *Konsul, Capital* (39) and *Town Tower* (38) of 1962 finds a much clearer and firmer development in brass and gun metal. The technical procedure is, of course, substantially different from the previous stamp-and-cast process. Paolozzi designs the basic form of the sculpture, forms the individual elements in wax or in wood in order to test their plastic qualities, and then has them cast. They are then welded together under his supervision. The result is a unique example. The individual elements, having been tested, are used anew in other connections. These single pieces may be Paolozzi's inventions; they may be slightly modified *objets trouvés;* in most cases they have been designed after technical models—similar to the illustrations in spare-parts catalogues. The combination of these elements corresponds to the collage principle. Like the "images" in the graphics, they are precisely developed in the same way as a mass-produced industrial item; the welding seams show; they bear Paolozzi's personal mark. While initially the elements—in line with the collage principle—were still often cast from various materials, later on they are made almost exclusively of aluminium. The process here, as in the previous phase, is an ambivalent one: the collage process (combination of various elements) is captured by a material unification in the casting; however, the elements—due to the visible welding seams—are still recognizable as structural parts. The sculptures employing this procedure were done between 1962 and 1965; they have three basic forms: the towers—*Bride of the Konsul* (37), *Town Tower* (38), *Capital* (39),[29] the double towers—*Imperial War Museum* (41), *Twin Towers of the Sfinx II* (40), *Wittgenstein at Cassino I* (43), *Four Towers* (44), *Twin Towers III* (45), *Tower for*

14

Spontaneous Discrimination Non-Spontaneous Discrimination
Screenprint from: *Universal Electronic Vacuum*, 1968, 40 × 27″

Sun City
Screenprint from: *Universal Electronic Vacuum*, 1967, 40 × 27″

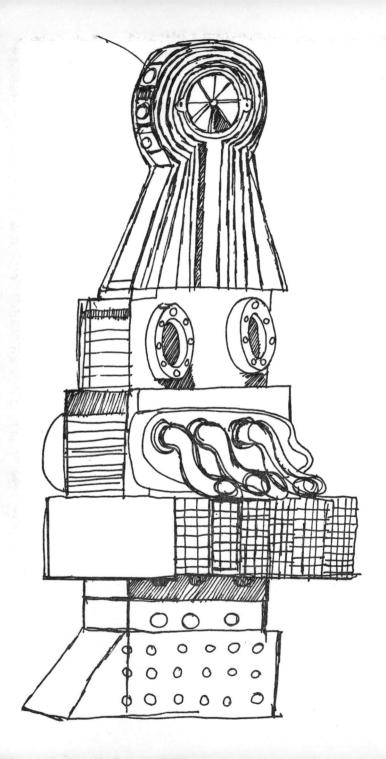

Mondrian (47),[30] and the "idols"—*The Last of the Idols* (48, left), *The Bishop of Kuban* (48, right), *Diana as an Engine I* (49, left), *Hermaphroditical Idol* (49, right); the last is bronze.

They all share a severe tectonic structure and have their own bases as part of their bodies; they have their own crowns. The departure point for the basic forms is no longer the constellation of human or animal bodies with legs, trunk and head, but rather—particularly in the double towers—architecture with a pedestal, structure, crown and a central motif in the middle axis. The variously structured and formed elements are symmetrically arranged at the sides of the central wheel-form motif. The sculpture is constructed.

The references to reality are again ambiguous. The single parts allude to the world of machines; they are reminiscent of ventilators, cylinders, switchboards, vent valves and insulators. The structure of the sculptures is analogous to that of architecture: strangely enough, association with a cathedral façade comes to mind: double towers and rose window.

The characteristic feature in this phase is that the sculptures cannot be unequivocally defined; they stand at the intersection of references. Paolozzi expressly wants to "find some kind of clues outside of the orthodox art channels, including outside modern art, outside contemporary zones, some kind of means of constructing something without necessarily resorting to programmatic art."[31] That Paolozzi owes hardly any debts to previous sculptors, that he stands alone with his sculpture, is in no small way attributable to his intentions in the 'fifties, which undergo their pictorial development here. The artistic entity is not supposed to be an esoteric work of art, but rather an artefact, the form of which relates to man-made objects and which, in turn, assumes a place among these man-made objects.

These sculptures make no claim to unique meaning. One would misunderstand them if one were to see metaphysical relationships in them. Their peculiarity consists in the realism of invention,

Drawing for a sculpture, 1963. Height 10¼″

6228. *Plus: Cry On My Shoulder, No Sad Songs, etc.*
Lithograph and screenprint from: *Zero Energy Experimental Pile*, 1970
30 × 20 ″

Will the Future Ruler of the Earth come from the Ranks of the Insects
Lithograph and screenprint from: *Zero Energy Experimental Pile*, 1970
30 × 20 ″

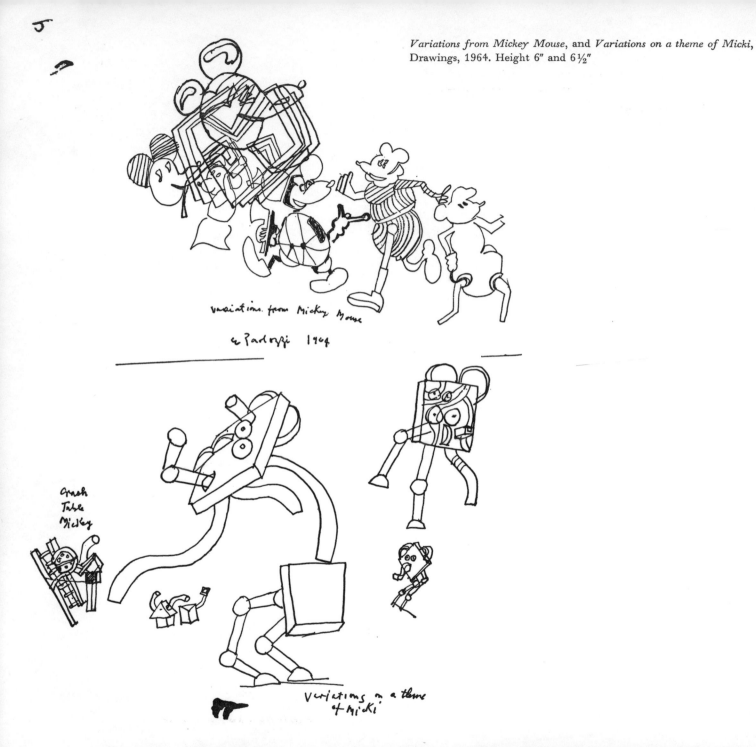

adaptation and structure; it consists of the fact that these structures create in the viewer a definite range of associations demarcated by architecture and mechanics. They can neither be categorized as art figures nor dismissed as machines: Paolozzi allows both of them a place in the new entity. The powerful presence and fantastic realism of this entity still remain somewhat strange, despite all the noticeable fascination for the viewer, because they are less susceptible to empathetic penetration and sensual discovery (as, say, in Henry Moore) than to rational perception.

"I was trying to make a specific image which depended partly on the real radial engine and partly on a certain casting designed by me... Early forms of society worshipped an image of a symbol which represented some dominant force, and I see something related to this today when one does a precise or specific image which represents in a small way the kind of man-made forces which contribute to certain man-made articles I am involved in."[32]

Despite his directness, Paolozzi wants to create symbolizing forms in his works. For him, Mickey Mouse in graphic works is just as much a symbol as the wheel. Of course, they are rationalistic symbols based upon modern civilization which *a priori* removes them from the symbols of the medieval sacral world. But, the representative is also intrinsic to them. Paolozzi wants to develop a lasting form which starts from everyday commodities but which resists their normal depreciation process. The underlying factor is the "search for archetypes",[33] for contemporary and (therefore) rationalistic archetypes. Paolozzi himself speaks of "idols" which, however, are freed from all metaphysical components. It almost appears as if he builds new idols of a rationalistic age upon the basis of his previous phase, which put old idols in question, or indeed made their decay manifest. The fact that he relates more to the world of mechanics than to that of the computer may arise from the latter's invisibility.

With plastic elements and basic forms developed for only one occasion, Paolozzi creates series of sculptures which overlap each other in time; the single pieces recur often and the structural constellations turn up again with small variations. One of the first sequences was done in 1962. Of the six works (three in bronze, three in aluminium) only one (*Solo*) is preserved—Paolozzi destroyed the others. *Solo* (42) was subsequently chrome-plated, when he reworked a whole series of sculptures from this phase some years later (1964–66); that is, he painted their surfaces. Among these are *Wittgenstein at Cassino I* (43), *Tower for Mondrian* (47), *The Last of the Idols* (48, left), *The Bishop of Kuban* (48, right) and *Diana as an Engine I* (49, left). As a rule, he uses the same basic illuminating colours which characterize the geometrizing zones in his screen prints. The carefully delineated colours serve to distinguish the individual plastic and structural parts. Now they contrast with one another more clearly and emerge more strongly as collage elements. However, the monumentality of the formerly flat, silver-grey aluminium sculptures is diminished by the toylike motley. Here, as always for Paolozzi, the emphasis of one aspect entails the concurrent reduction of another (dialectical principle).

Paolozzi had no sooner found new, clear forms in the towers, double towers, idols and the *Solo* series of 1962/63 (an astonishingly productive spurt) when they, in turn, were put in doubt with *Towards a New Laocoon* (51) and *Mekanik's Bench* (50) – both 1965. In *Mekanik's Bench* he again introduces his materials—analogous to *Table Sculpture* (27) of 1948/49; he presents his "grammar of forms" and to a certain extent draws a balance. In *Towards a New Laocoon*,[34] the elements are united, but more in the sense of an assemblage than a machine-architecture. The rigidly symmetrical structure has been abandoned; a new freedom of movement seems to stimulate Paolozzi. His relationship to the world is not fixed enough for him to be able to formulate it in the same manner again and again in endless test series. Paolozzi is not the type of artist who is bent upon continuity and linear development; just as he is not an artist bent upon art alone.

Towards a New Laocoon is a *résumé* displaying the whole arsenal of forms from the previous two years; at the same time it is a reference to the dismissal of this arsenal of forms for the benefit of new plastic ideas. And when the *résumé* is repeated in 1965 in *Rio* (55),—an environment-assemblage—the structural principle had already been declared pictorially senseless in *Crash* (52/53)[35] of 1964, with its chaotic confusion of the parts. The repertoire of

forms appears here to have become the victim of an attack or a collision; practically all the parts are twisted, and the previously central wheel motif is lying on the ground; above it tower the remains of a destroyed order. *Crash* once again makes the pursuit of the sculptor the theme of a work; *Crash* signifies the end of the monumental phase in Paolozzi's work.

However, the year of *Crash* also saw the first new sculptures out of the ruins: *Medea* (56) and *Poem for Trio MRT* (57), both 1964.[36] What remains of *Crash* is the space-gulping tubular sprawl, otherwise nothing. The symmetrical structure is abandoned just as is the multiplicity of motifs. A textured box-form is supported by twisted aluminium coils, which are produced out of the multiple use of standardized tubing. The piece does not have its own pedestal; it stands on the ground with several feet. The essential difference from *Crash* is that the coil forms in *Crash* are the products of a violent alteration; here they emerge quite naturally as newly-wrought motifs. The technical-looking organization and static-appearing design of the preceding phase are superseded by dynamic, open forms[37] which finally lead, by way of *Rizla* (58) and *Marok-Marok-Miosa* (59), both 1965,[38]—with their standardized cast elements—to *Neo-Saxeiraz* (1966; 60) and *Etze* (1967; 61)[39]: simple structures of one or two motifs which claim to be no more than objects without substantial content. Paolozzi, 1965: "The sense is here, however, nothing; the picture everything."[40]

Prior to *Etze*, Paolozzi's sculptural form-world had changed substantially. He was no longer stimulated by the cross-references to machines and architecture, nor the dialectical relationship of destruction and construction, but rather by the physical experience of plastic qualities in space achieved with elementary forms. The two primary aspects of the earlier works have given way to an all-round aspect. The convolutions of sculptures, joined together by straight and semi-circular tubes, rise up from the ground, lie over one another and tower stiffly into space. They are odd structures, but it is by way of this oddity that they address the spatial-plastic sensorium of the viewer who now sees nothing more than forms whose content and meaning are precisely their form. The form is not—as one has learned to expect from the habitual intercourse with artistic products—heightened by the intellect; the traditional mind-body conflict is eliminated. The object (emphasized by the polishing) has an objective appearance without any essential personal marks. The object is nothing more than itself. From this point of view, Paolozzi's sculpture in this period is very close to Minimal Art. A variation of these object-sculptures is presented by *Pan Am* (1966; 63) and *Mainspar* (1967; 62)[41] structured by the addition of standard elements.

Since about 1966, Paolozzi has very clearly undergone an experimental phase, in which not only new forms but new materials have been tried. For example, a book by the architect Erich Mendelsohn on glass architecture in Germany and the United States in the 'twenties so fascinated Paolozzi that he planned glass sculptures. In the experimental series, *Domino* (1967/68; 64/65) is less a sculpture than a pile of plastic elements. The nine pieces allude to several standard cast-forms, already employed in *Pan Am* and *Mainspar*, and can be arranged at will. Given the elements, it is left up to the viewer to conceive a sculpture conforming to his own ideas. Obviously, the collage principle is also the basis here, analogous to the screen-print box *Moonstrips Empire News*: fully developed components which in themselves could represent something finished, and which are available for transitory combinations. The theme of this sculpture is once again the sculpture itself, its continually new, three-dimensional appearance, its continually new form of spatial displacement; for the viewer who knows how to manage the elements it is a paradigm of corporality in abstract sculpture where content is identical with form.

Based on *Sumen-Suren* (1965/66; 66, right) Paolozzi developed a series of mostly small-format sculptures between 1967 and 1969; *Bhalk* (66, left), *Fepho* (67, left), *Twefx* (67, right)—all 1967.[42] These sculptures of chrome-plated steel are meant to be touched and looked at; they are free of all the previous dialectical relationships. Very delicately arranged concave and convex surfaces meet with barely perceivable, lightly rounded edges in a baffling play of form. If a modified form of the dialectic is to be seen in them at all, it is in the reciprocal effect between the plastic form and the various environments of this form, which are again distorted in the mirror

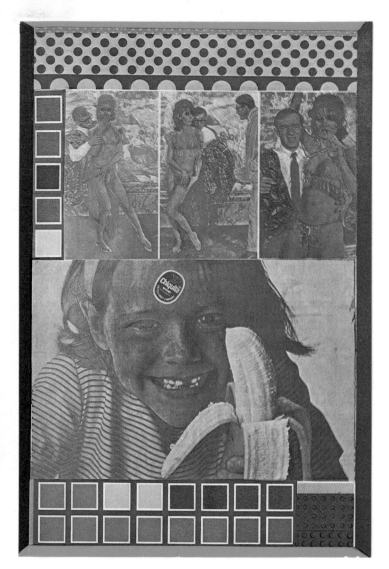

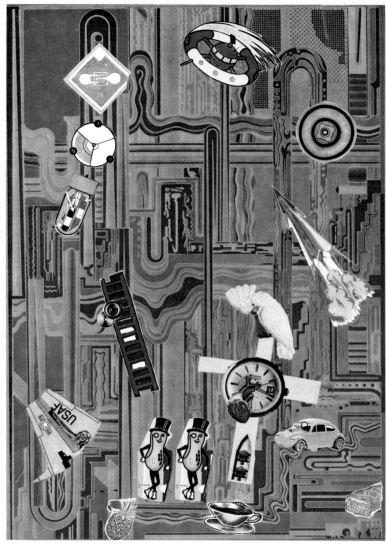

Banana
Screenprint from: *General Dynamic F. U. N.*, 1968, 15 × 10″

Mr. Peanut
Screenprint, 1970, 19½ × 27½″

of the sculptures. The shape of the sculpture, which must be sensually conceived and felt, is only one side of its effect. The other side is the dissolution or, in any case, the questioning of this shape through its distorted mirror effects. Thus, the form of the sculpture is separated from its effect : the border between the two is permeable; optical values have been added to the plastic values and the optic are not always congruent with the plastic.

Thus, these steel sculptures from the fifth phase in Paolozzi's work invoke neither symbols nor idols, but are purely aesthetic objects. The plastic object with its reflections and distortions acquires an aesthetic function within its environment.

The peculiar titles of these sculptures are intended to deter all the usual associations and divert the attention to the optical and plastic qualities. In some cases they are arbitrarily modified proper names, but often they are concepts from a field having nothing to do with art : Paolozzi took them from a listing of international telegraph codes. The title's content has no significance for the sculpture.

It is fascinating to see how Paolozzi now, out of dissatisfaction with the simple form of sculpture, harks back to the late 'fifties. The principle of destruction—at the same time construction—is inverted. Paolozzi develops or adopts the finished form of a high-rise building or an automobile and subjects it to a destructive process. However, the initial form is still recognizable in the final product, recognizable as a destroyed initial form. He is making manifest the fact that man performs two acts at once : he builds admirable high-rise buildings and consistently destroys them by wars; at the same time that he is building outstanding automobiles, he is demolishing them *en masse* in accidents. The one is ineluctably bound to the other. Paolozzi's simultaneous portrayal of the creative and destructive forces in man is made possible by his prodigious talent for embodying dialectical relationships in sculpture.

[1] See Peter Selz in Exhibition Catalogue, *Eduardo Paolozzi—A Print Retrospective*, Berkeley, University of California, 1968, unpaged.

[2] See Lawrence Alloway, *The Development of British Pop*. In: Lucy R. Lippard, *Pop Art*, New York–Washington, 1966 (English edition, London, 1966).

[3] Richard Hamilton in the Exhibition Catalogue *This is Tomorrow*, London, Whitechapel Gallery, 1956.

[4] After Diana Kirkpatrick, *Eduardo Paolozzi*, typewritten dissertation, University of Michigan, 1969, p. 9.

[5] Paolozzi in the Exhibition Catalogue *Eduardo Paolozzi*, Cambridge, Arts Council Gallery, 1957.

[6] Eduardo Paolozzi, "Notes from a lecture at the ICA." *Uppercase* (London), No. 1, 1958, unpaged.

[7] French film pioneer (1861–1938) who inspired primarily the Surrealists with his filmed magic tricks. On occasion, monsters play an important role in his films, for example, in *A la conquête du Pôle* (1912).

[8] Eduardo Paolozzi, "Notes from a lecture at the ICA."

[9] Franz Mon, "Arbeitsthesen zur Tagung 'Prinzip Collage'," *Prinzip Collage* (edited by Institut für moderne Kunst, Nürnberg), Neuwied/Berlin, 1968, p. 13.

[10] Cited by Jürgen Claus, *Kunst heute*, Hamburg, 1967, p. 208.

[11] Jasia Reichardt, "Eduardo Paolozzi," *Studio International*, 168/858, 1964, p. 154.

[12] The collage principle can also be found in his texts, as, for example, in the pseudo-interpretation "Analysis of Domains or the Spectrum of Alternatives." English and German in the Exhibition Catalogue *Eduardo Paolozzi—Plastik und Graphik*, Düsseldorf, Städtische Kunsthalle, 1968/69, pp. 11–16, and in "Moonstrips," German in the omnibus volume: *Neue englische Prosa*, Cologne, 1970.

[13] Marcel Duchamp's *Green Box* of 1934 with the title *The bride stripped bare by her bachelors, even* is similarly laid out. It contains 94 photographs, drawings and notes from the period between 1911 and 1915 which were done in connection with the *Large Glass* (1915–23).

[14] See Herta Wescher, *Die Collage. Geschichte eines künstlerischen Ausdrucksmittels*, Cologne, 1968, as well as Jürgen Wissman, *Collagen oder Die Integration von Realität im Kunstwerk. Poetik und Hermeneutik* (edited by W. Iser), Munich, 1968, pp. 327–360, cf. Note 9.

[15] Wissmann, Ibid, p. 327.

[16] The auction catalogue *Dokumentationsbibliothek III*, Bern, Kornfeld and Klipstein, 1968, provides information on the inventory of the former collection of Tristan Tzara. It appears that Tristan Tzara had a particular predilection for the *dessins mécaniques* of Picabia and Max Ernst

[17] "Notes on the film *The History of Nothing*," Eduardo Paolozzi, *Metafisikal Translations*, London, 1960, unpaged.

[18] These include *Forms in a bow I* (1949), Tate Gallery, London, and *Forms in a bow II* (1949/60), in the artist's collection.

[19] A similar table sculpture by Paolozzi titled *Icarus* (1949), a uniquity, is in the collection of Martin Richmond, London.

[20] A later variation is Paolozzi's *Chair* (1967) where the vocabulary is arranged on a chair.

[21] Included here are also *Jason* (1956), Museum of Modern Art, New York; *St. Sebastian* (1957), Solomon R. Guggenheim Museum, New York; *Greek Hero* (1957), Hanover Gallery, London; *Boxer Headed Figure* (1957), in the artist's collection; *Very Large Head* (1956), collection of Mrs. H. Gates-Lloyd, Washington; *Head* (1956), in the artist's collection; *Large Frog* (1958), David E. Bright, Los Angeles.

[22] Eduardo Paolozzi, "Mein Diktionär," *blätter + bilder*, no. 7, 1960.

[23] Edouard Roditi, "Eduardo Paolozzi," *Dialogues on Art*, London, 1960, p. 156.

[24] Roditi, Ibid, p. 159.

[25] Roditi, Ibid, p. 155.

[26] Also included here are *Little King* (1958), Minneapolis Institute of Arts; *9XSR* (1958/59), in the artist's collection.

[27] Jean Dubuffet, *The Ragged One*, 1954, Mr. and Mrs. Gordon Bunshaft, New York. See exhibition catalogue *The Work of Jean Dubuffet*, New York, The Museum of Modern Art, 1962, p. 88.

[28] Eduardo Paolozzi in exhibition catalogue *New Images of Man*, New York, Museum of Modern Art, 1959, p. 117.

[29] Also included here are *Konsul* (1962), Hanover Gallery, London; *The City of the Circle and the Square* (1963), Tate Gallery, London; *The World Divides into Facts* (1963), Hanover Gallery, London.

[30] In most cases these sculptures exist in several variations indicated by Roman numerals.

[31] Paolozzi in the interview with Richard Hamilton in: "Contemporary Sculpture," *Arts Yearbook* (New York), vol. 8, 1965, p. 163.

[32] Paolozzi in the interview with Richard Hamilton, ibid, p. 163.

[33] Eduardo Paolozzi, "Notes by the Sculptor," *Metallization of a Dream*, London, 1963, unpaged.

[34] Paolozzi was often concerned with Laocoon, as for example, in the film *The History of Nothing* (1962) and in the text for the screen print series *As Is When* (1965). There is a whole series of individual motifs which permeate Paolozzi's artistic products.

[35] One of the very few titles which makes some reference to the content of the sculpture.

[36] *MRT* stands for: Malevitsch, Rodchenko, Tatlin. This series of sculptures also includes *Lotus* (1964), Museum of Modern Art, New York; *Girot* (1964), Hanover Gallery, London; *Parrot* (1964), Mr. and Mrs. Albert List, New York; *Artificial Sun* (1964), Hanover Gallery, London.

[37] The formal sources can hardly be ascertained. On a sketch sheet from 1964 (see picture p. 18) Paolozzi playfully developed a plastic efformation from the figure of Mickey Mouse which resembles *Poem for Trio MRT*.

[38] Also included here *Akapotik Rose* (1965), Nelson A. Rockefeller, New York.

[39] Also included here *Gexhi* (1967) as well as the predecessors *Pisthetairos in Ipsi* (1965) and *Ovemk* (1966/67)—all three Hanover Gallery, London.

[40] *Wild Track for Ludwig*. Eduardo Paolozzi, *As Is When*. A series of screenprints based on the life and writings of Ludwig Wittgenstein. London, 1965.

[41] Also included here *Es Es* (1966) and *Study for Glass* (1967)—both Hanover Gallery, London.

[42] Also included here are *Twisprac* (1966), *Phaos*, *Ariina*, *Molik I*—all of 1967, Hanover Gallery, London, plus numerous others.

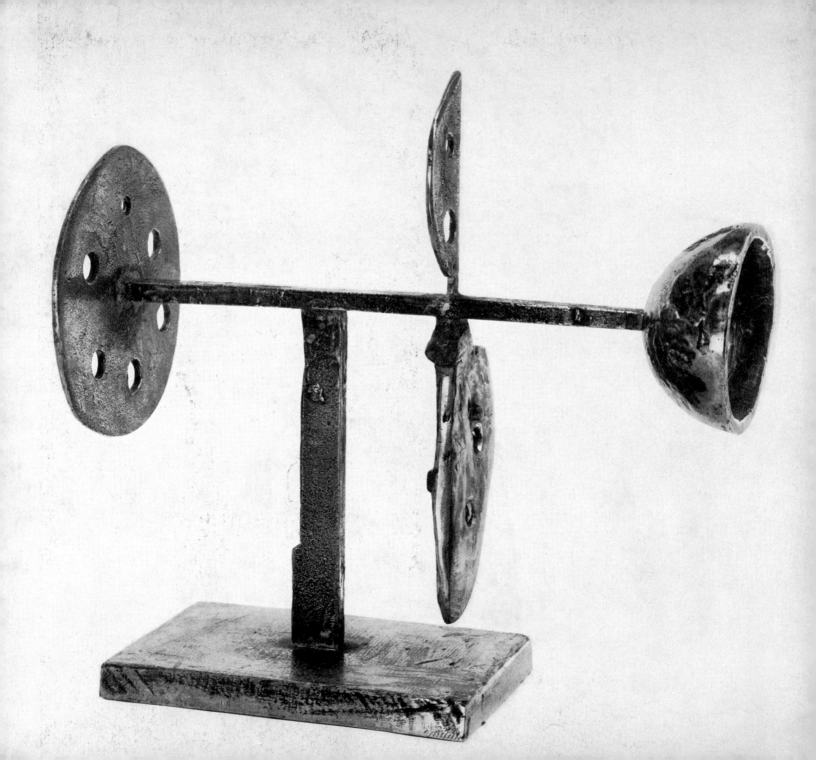

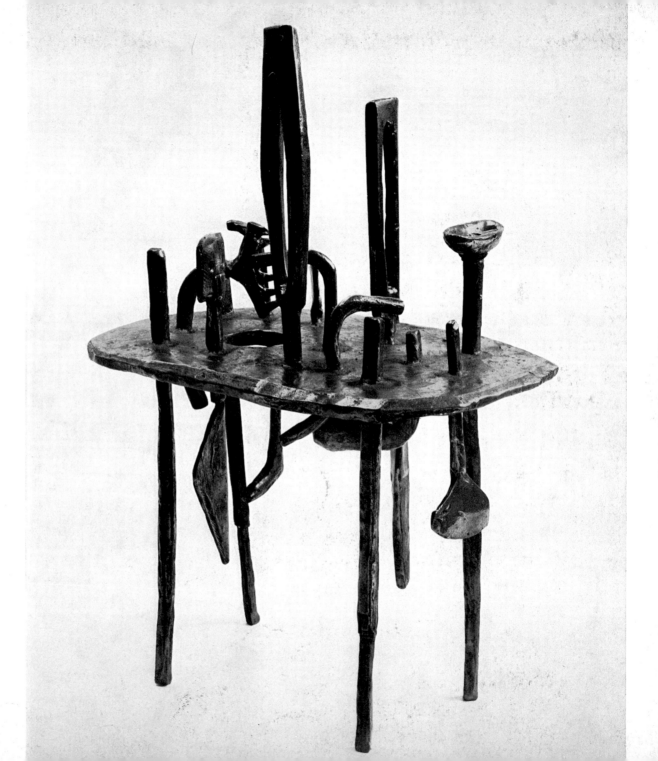

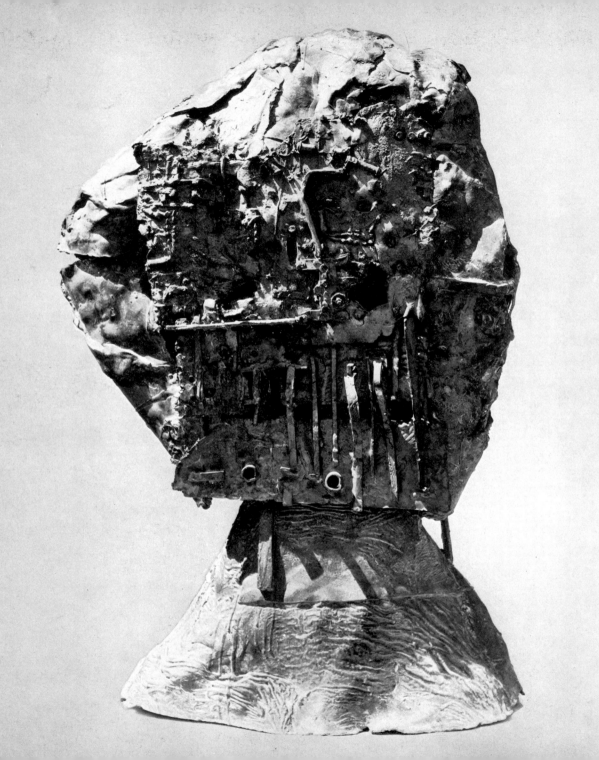

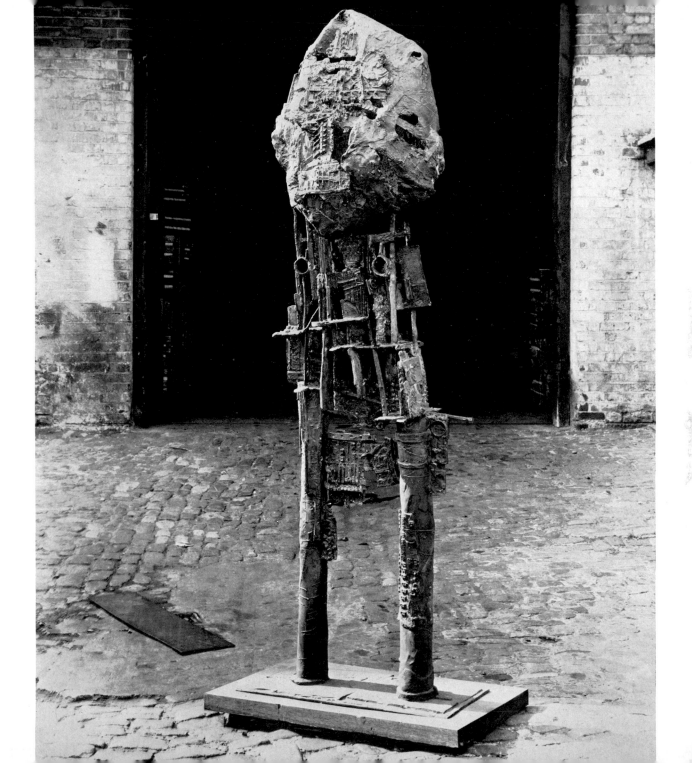

29

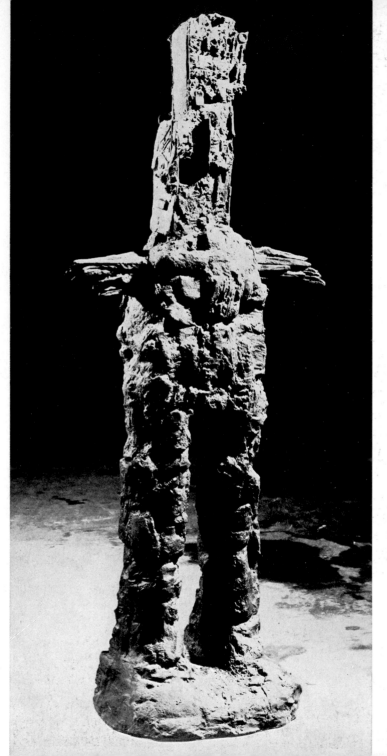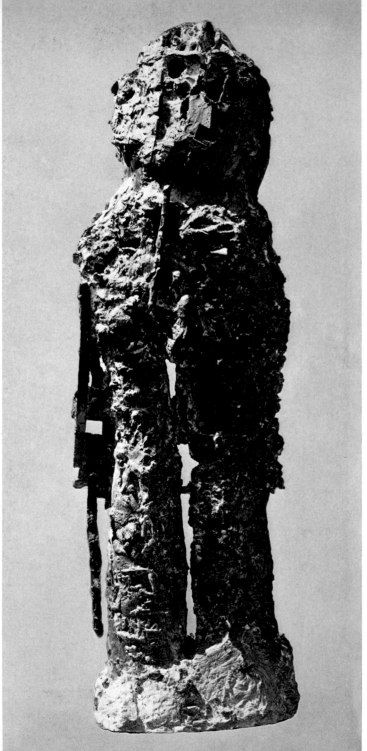

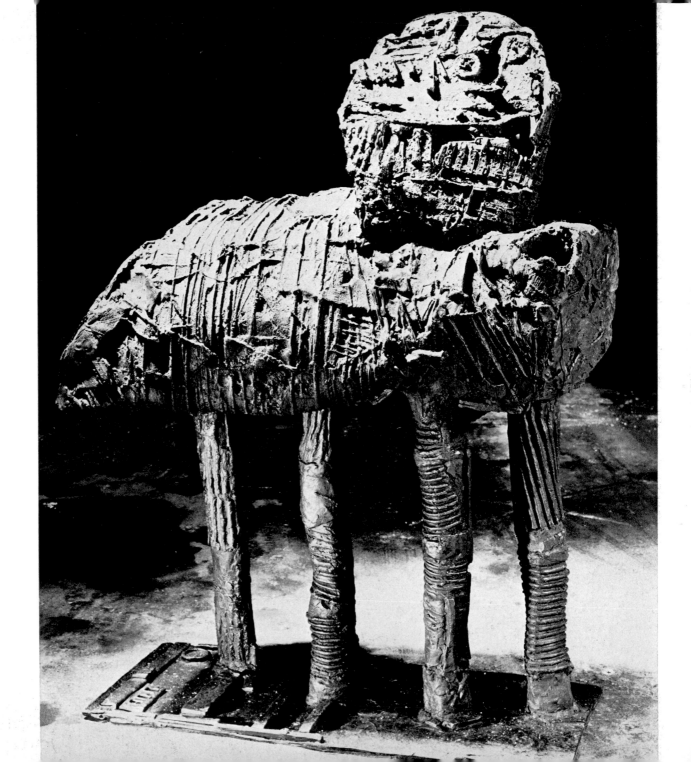

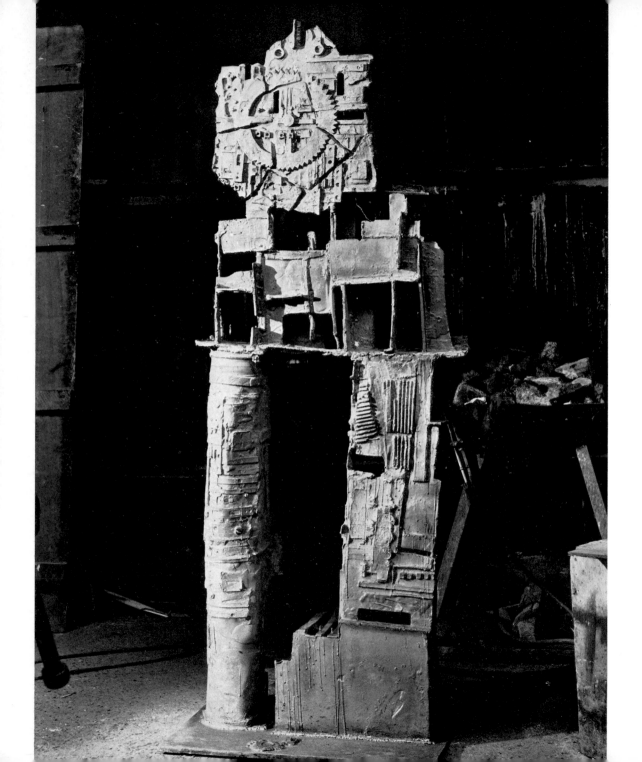

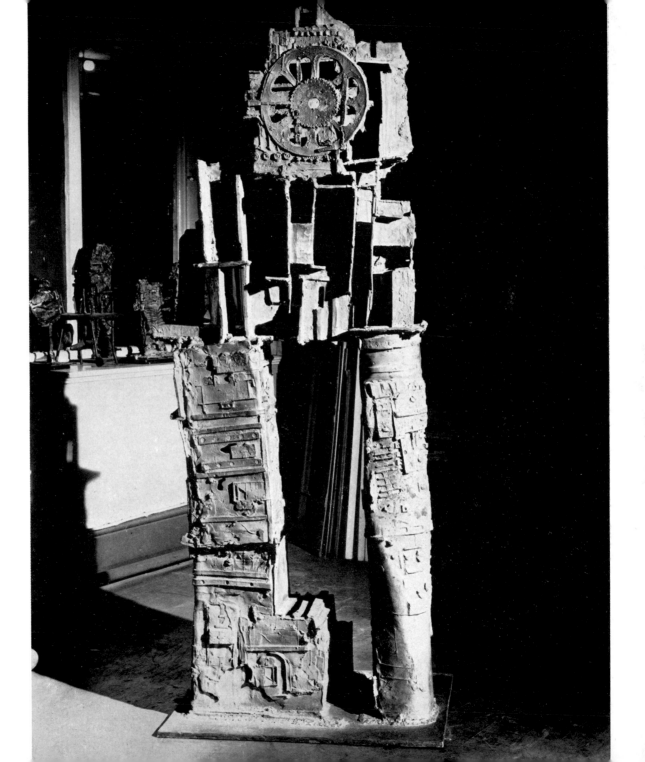

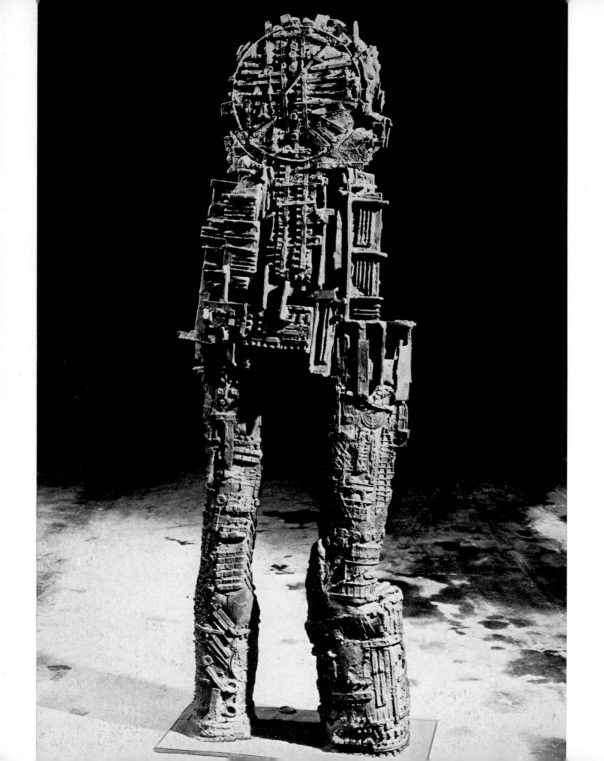

34

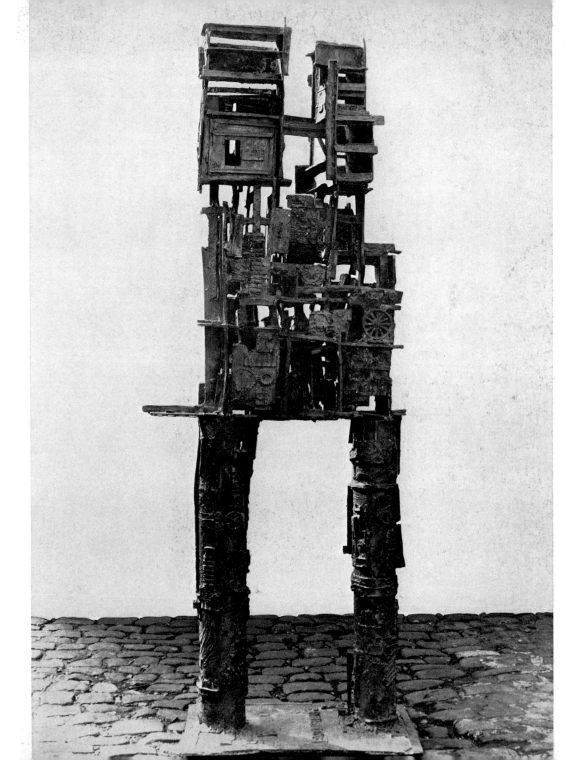

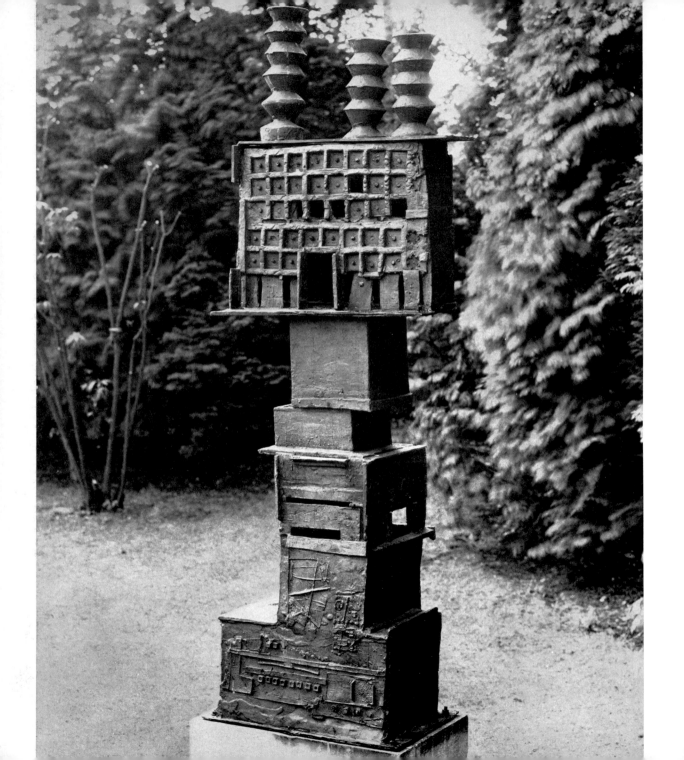

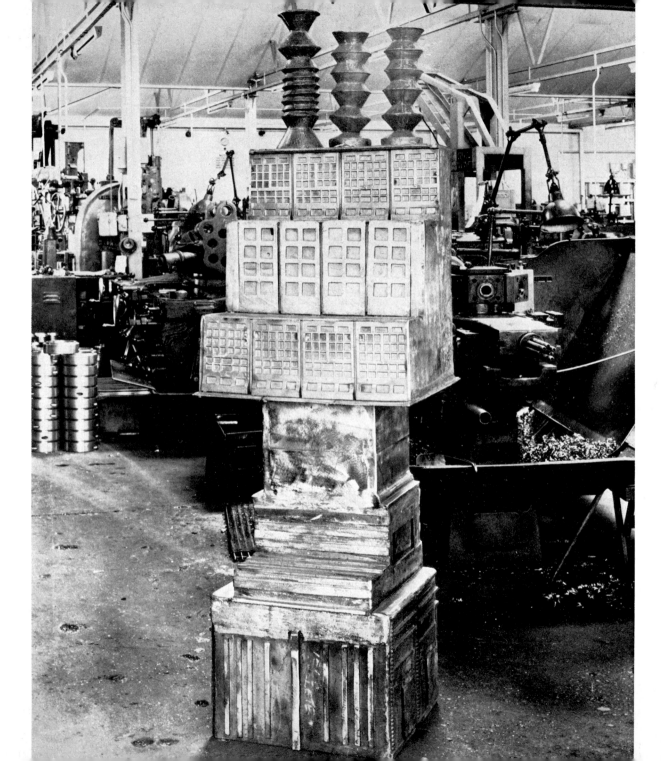

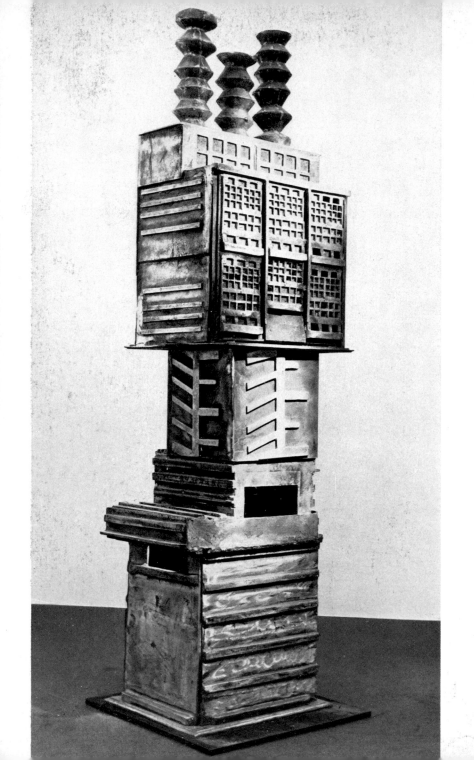

58

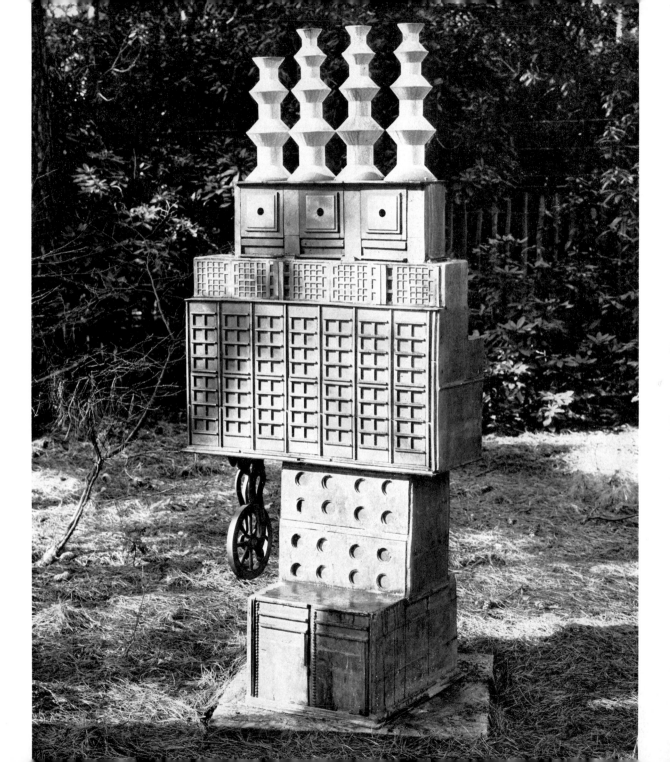

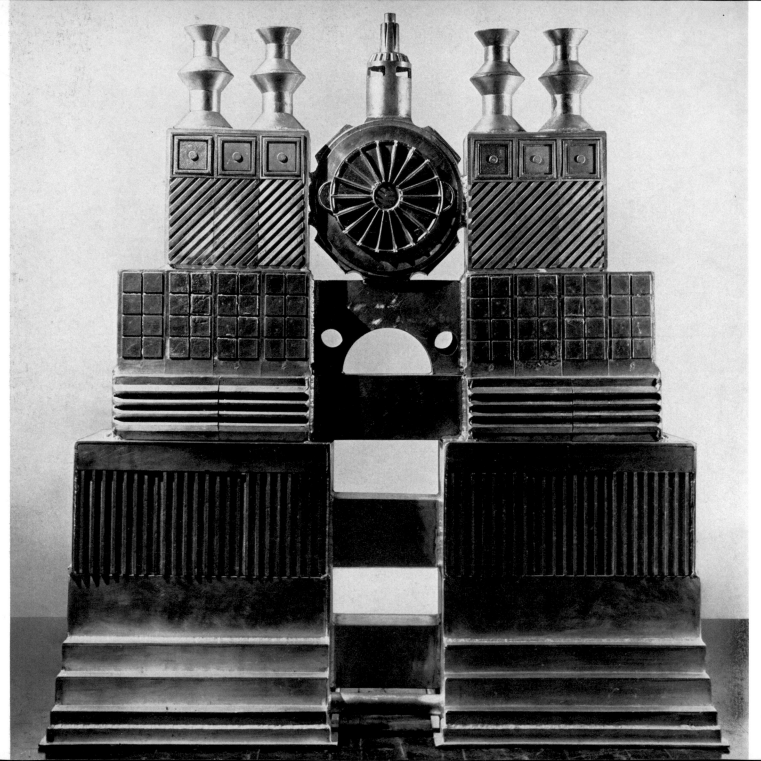

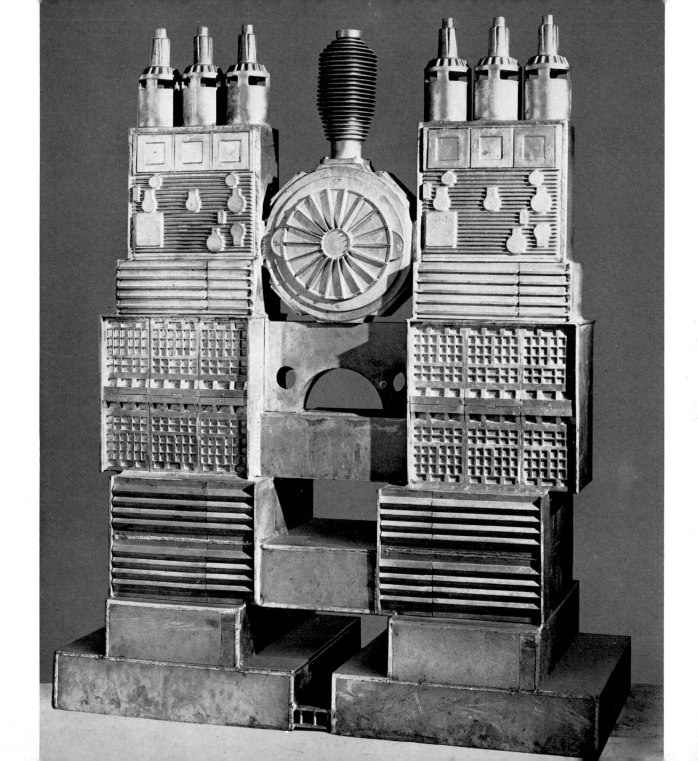

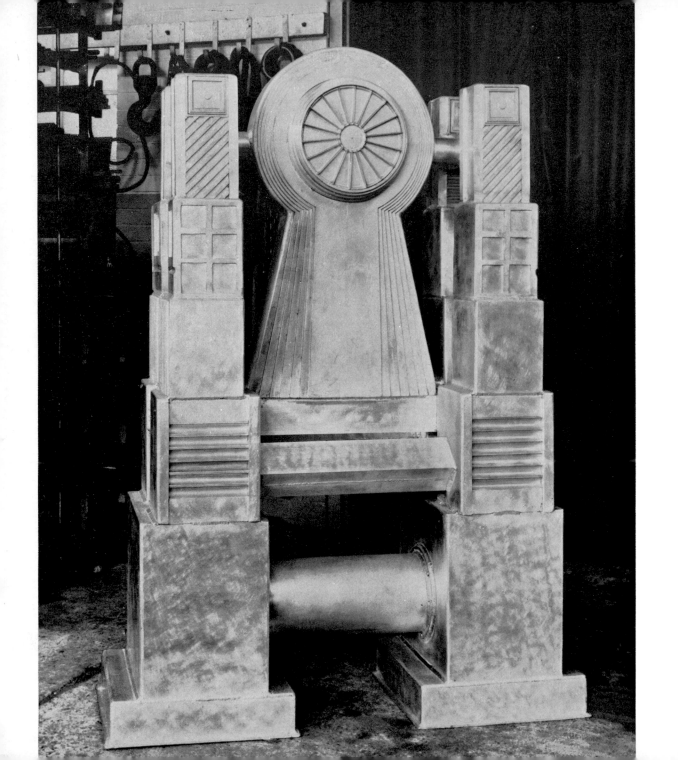

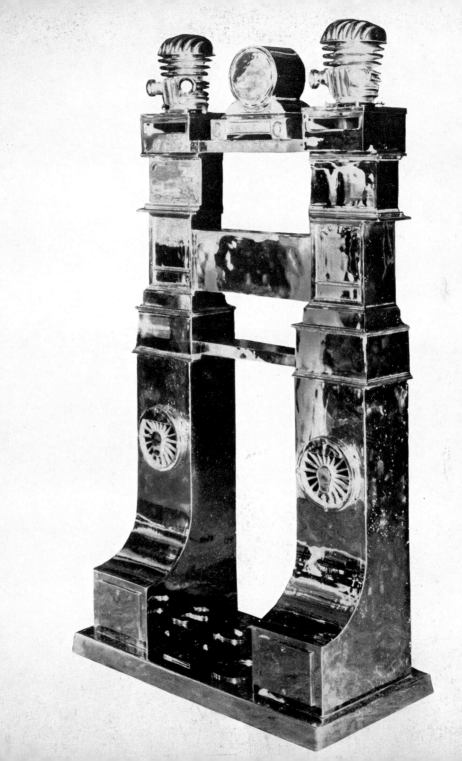

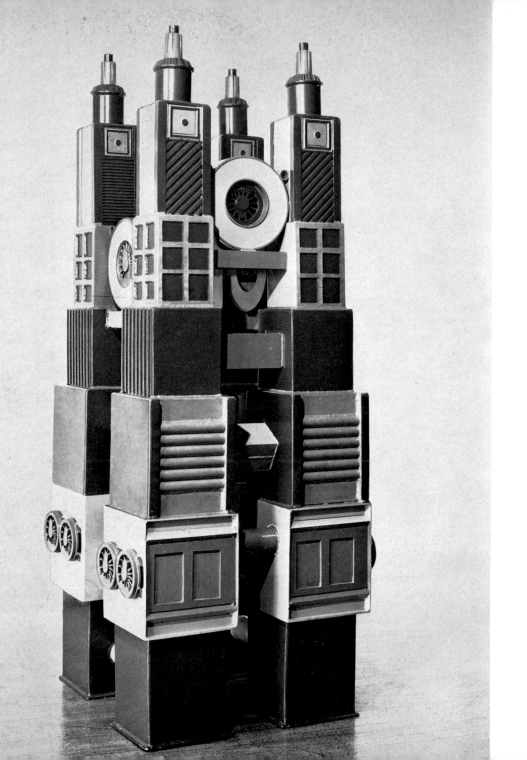

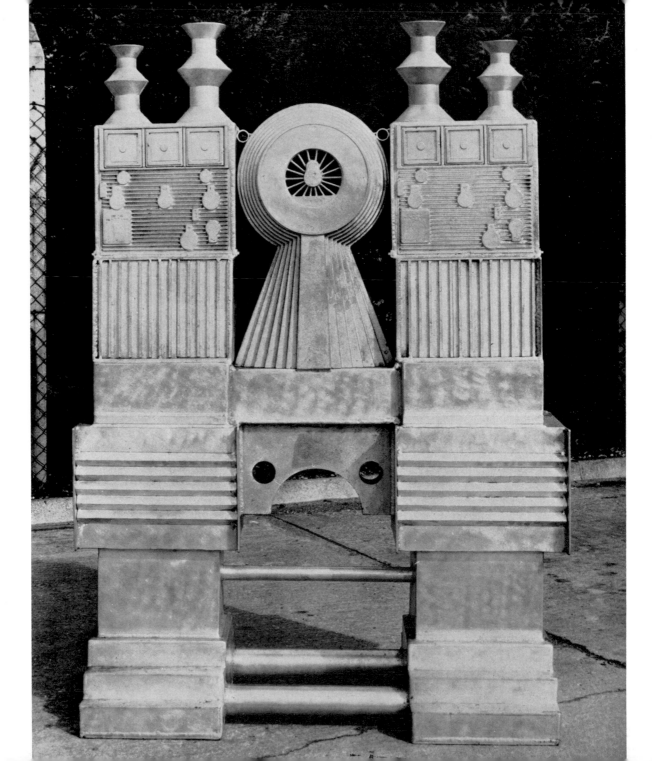

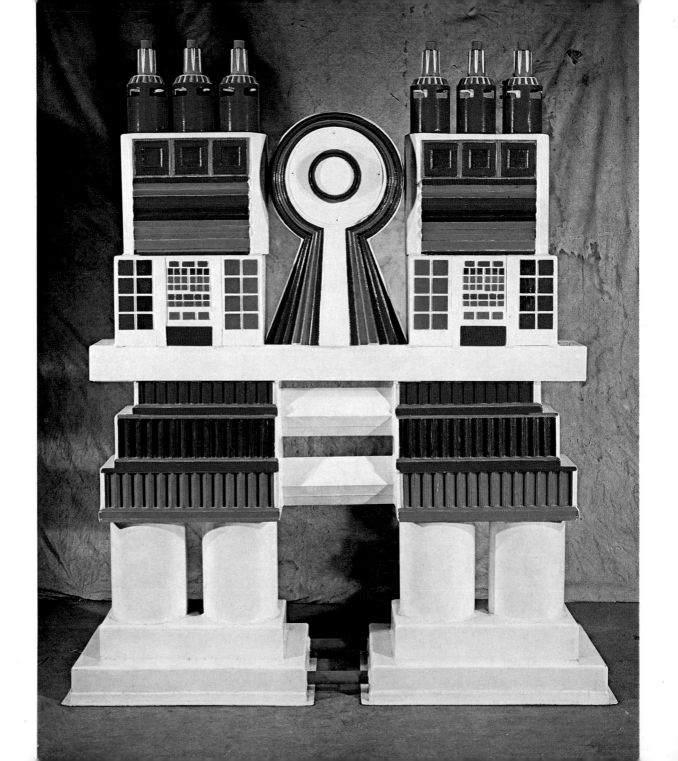

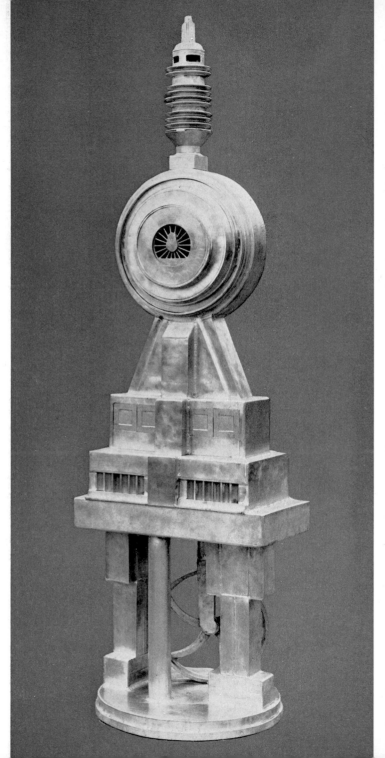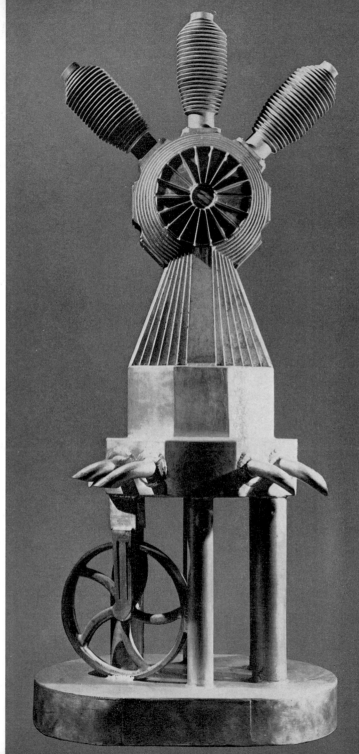

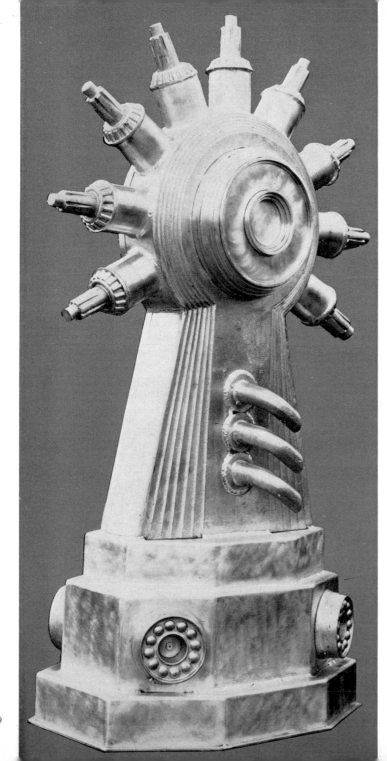
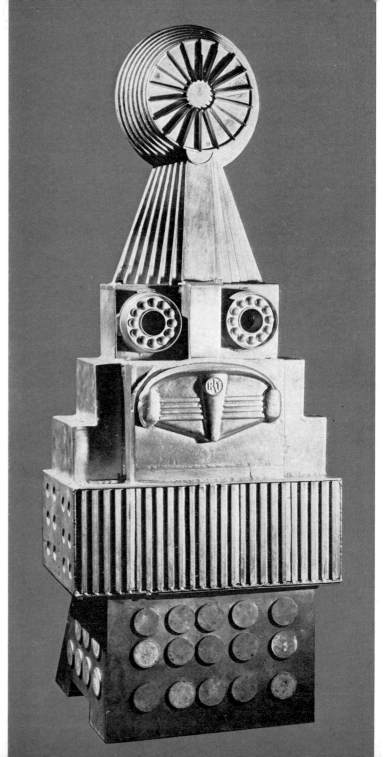

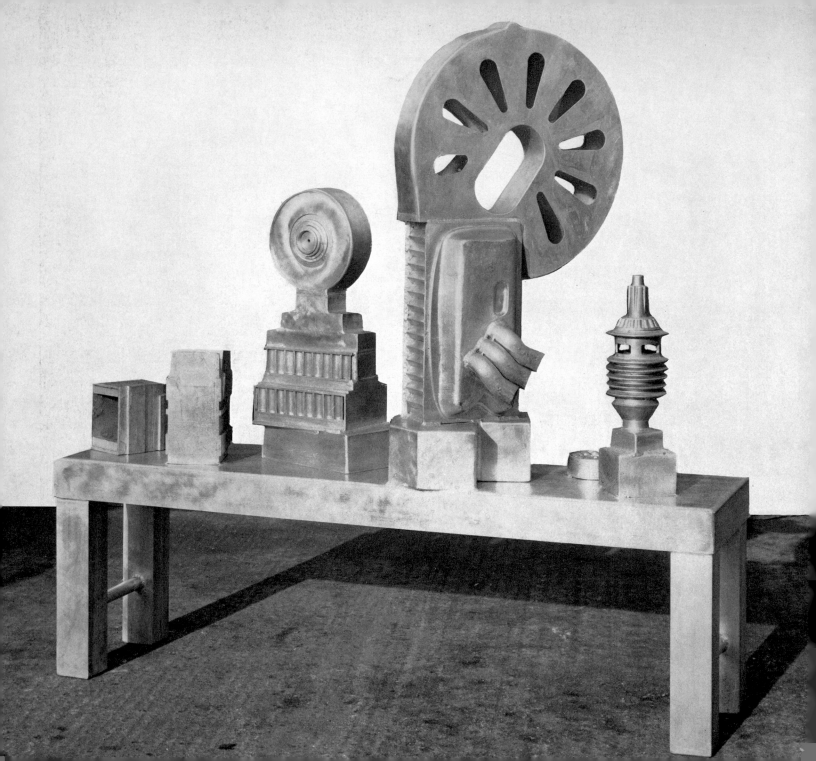

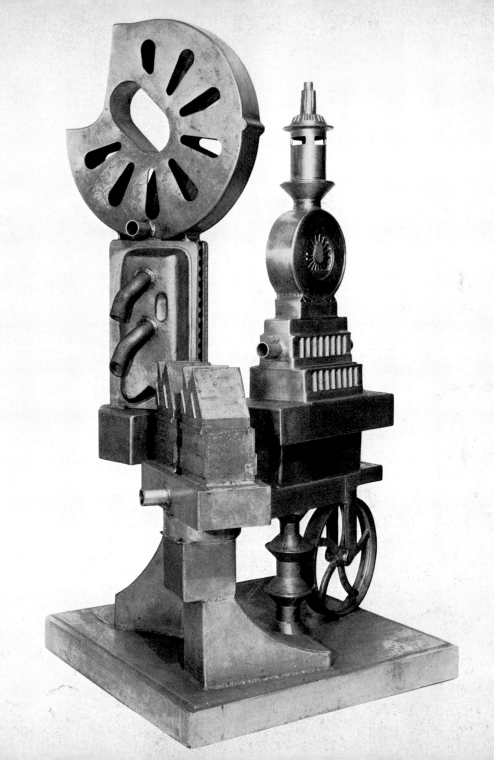

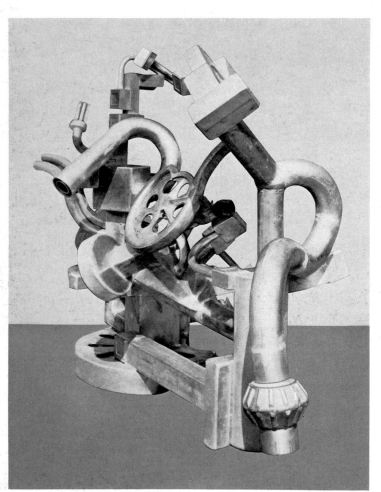
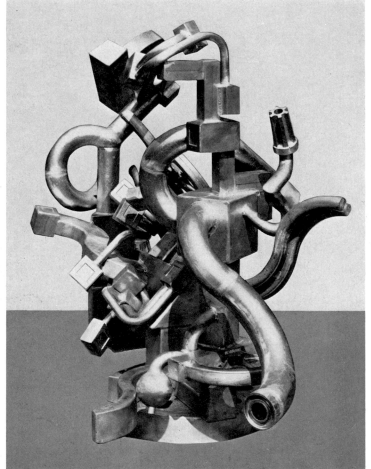

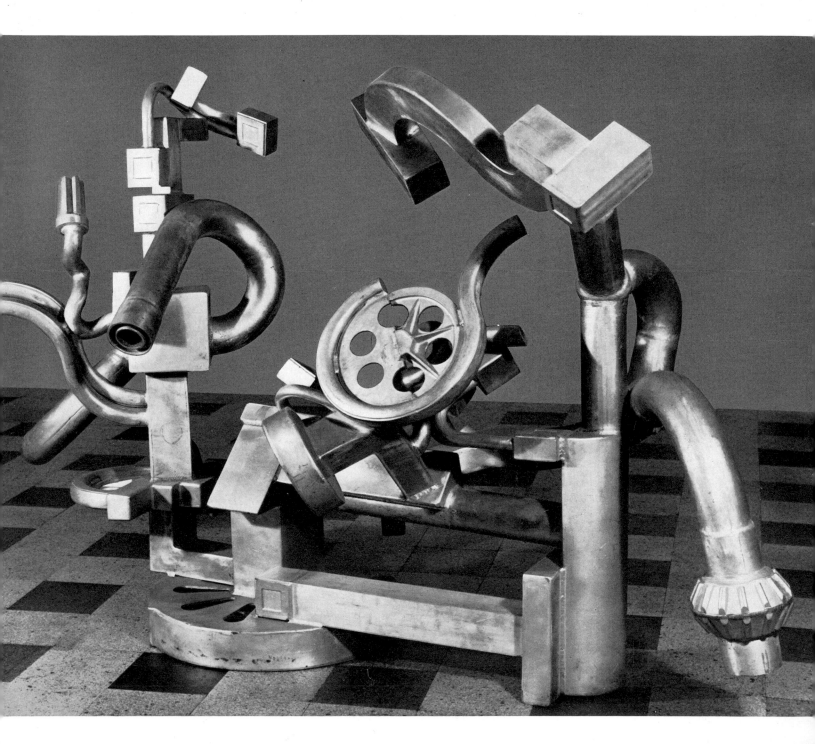

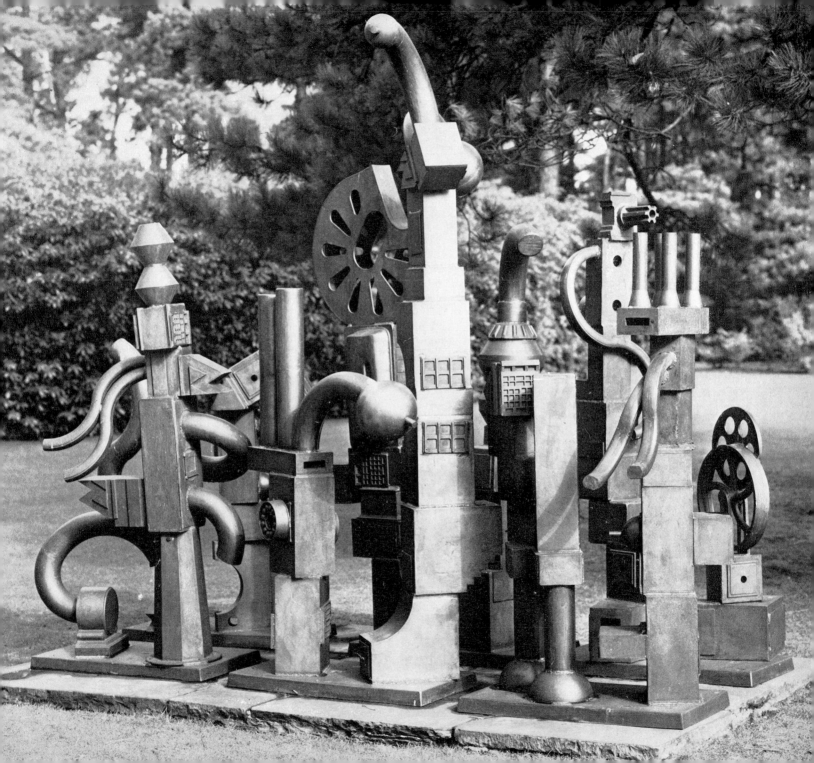

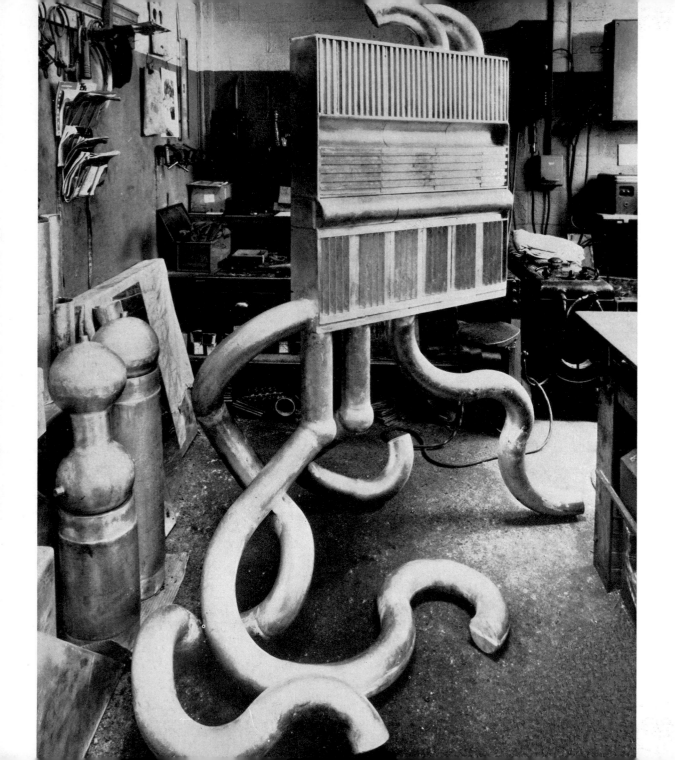

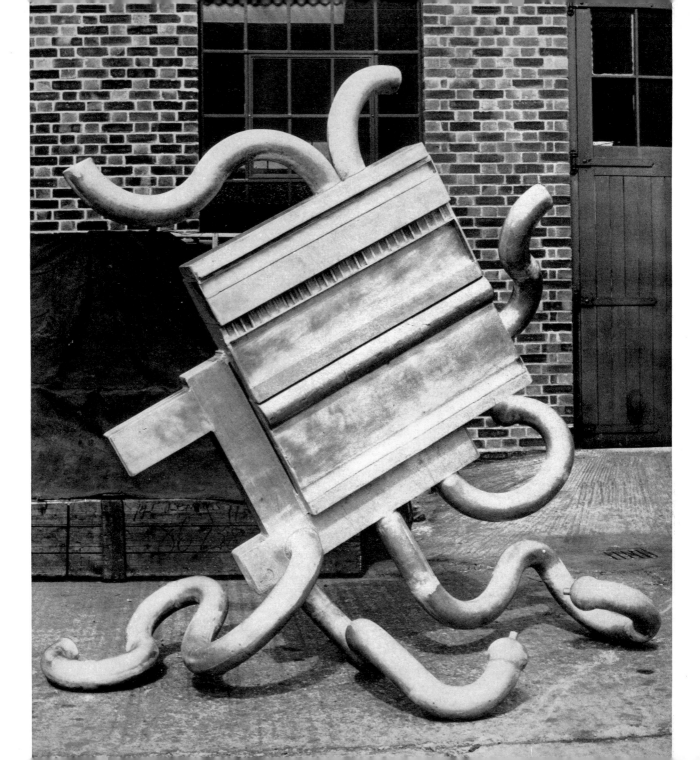

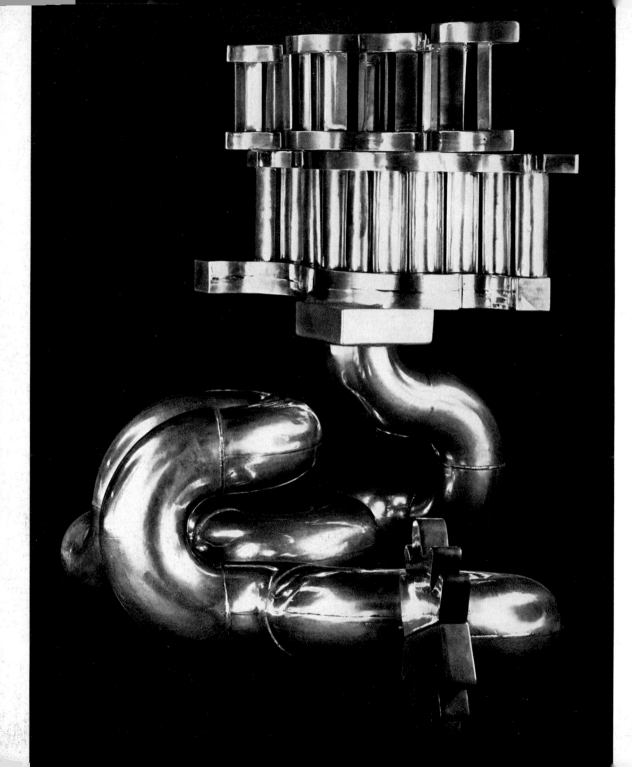

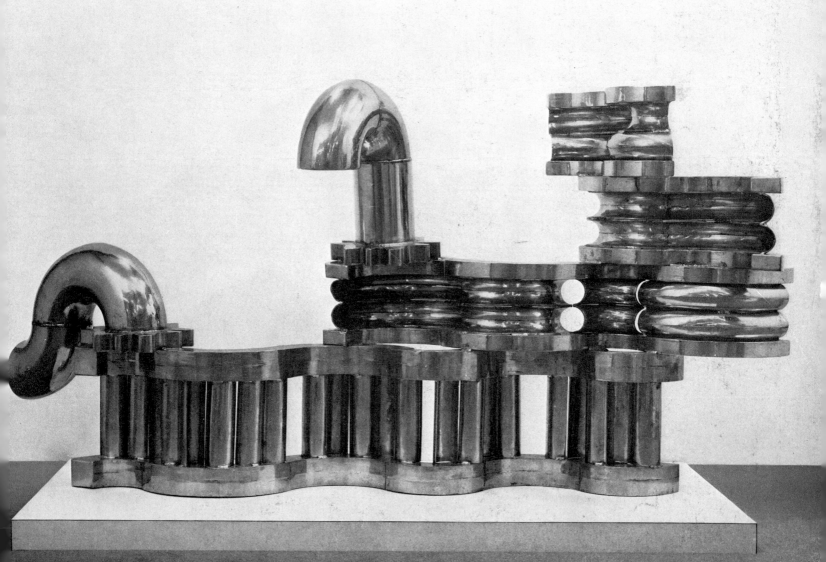

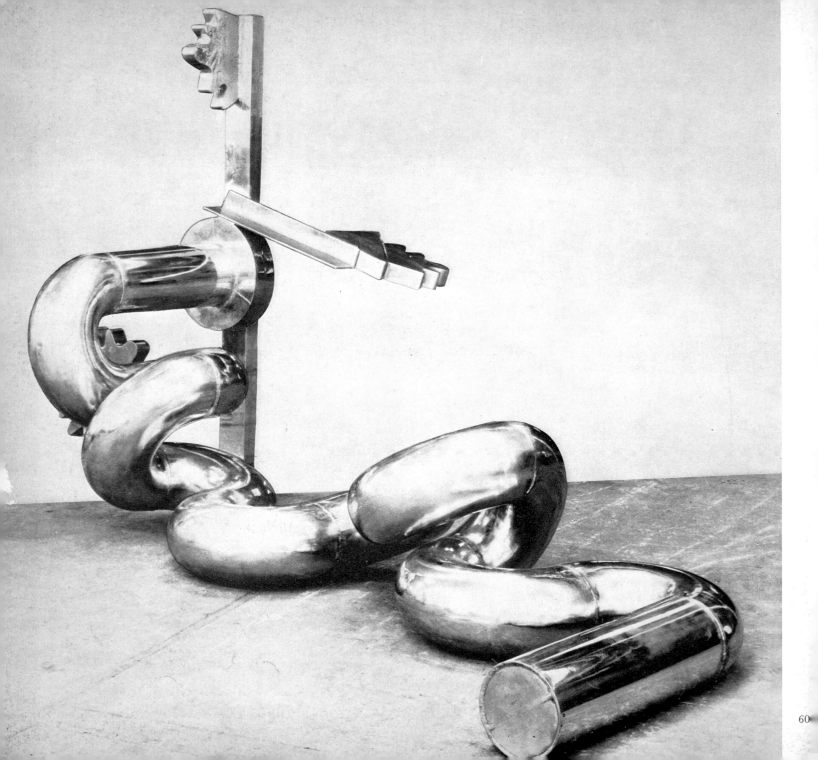

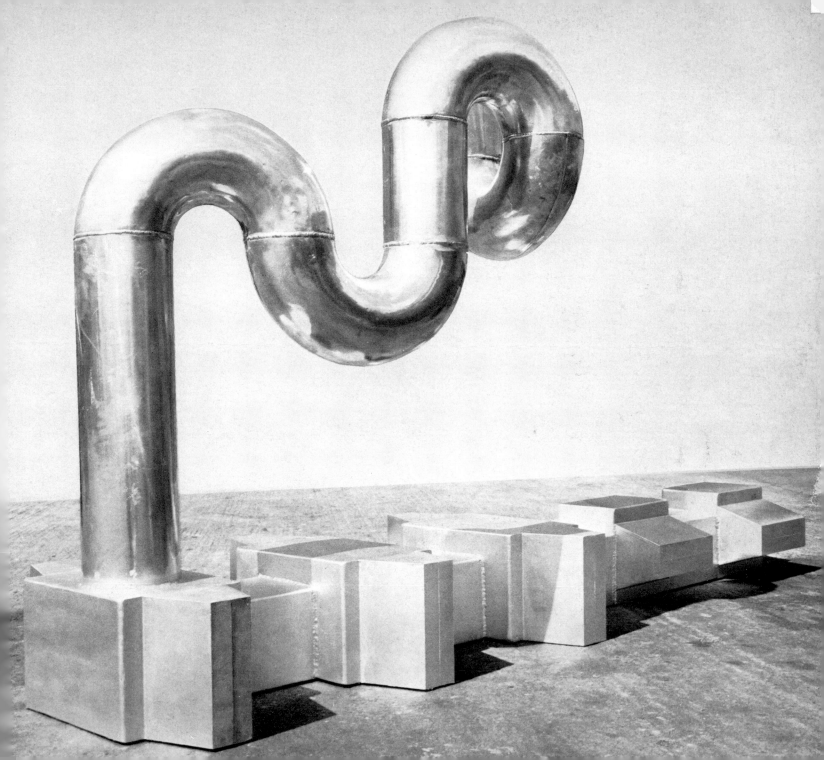

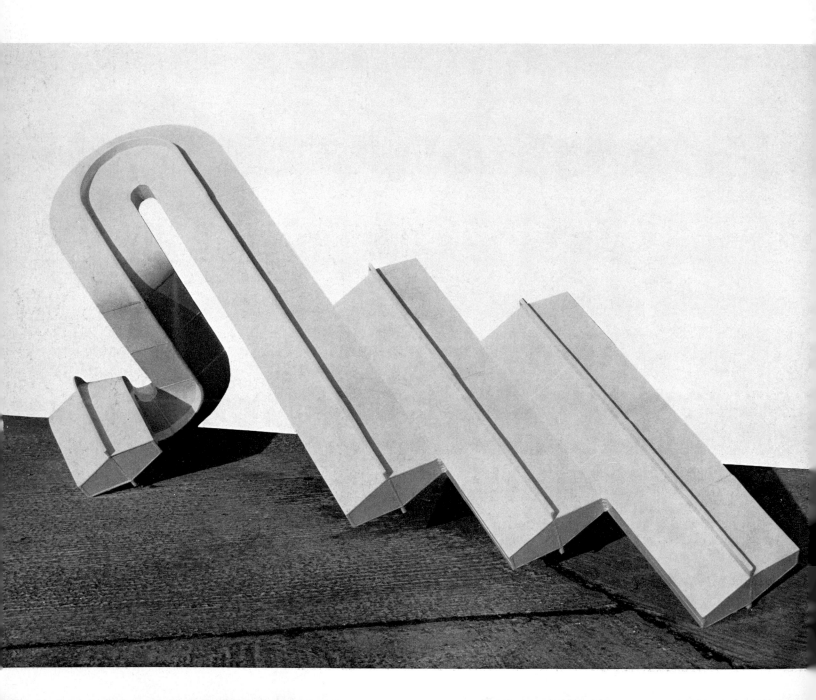

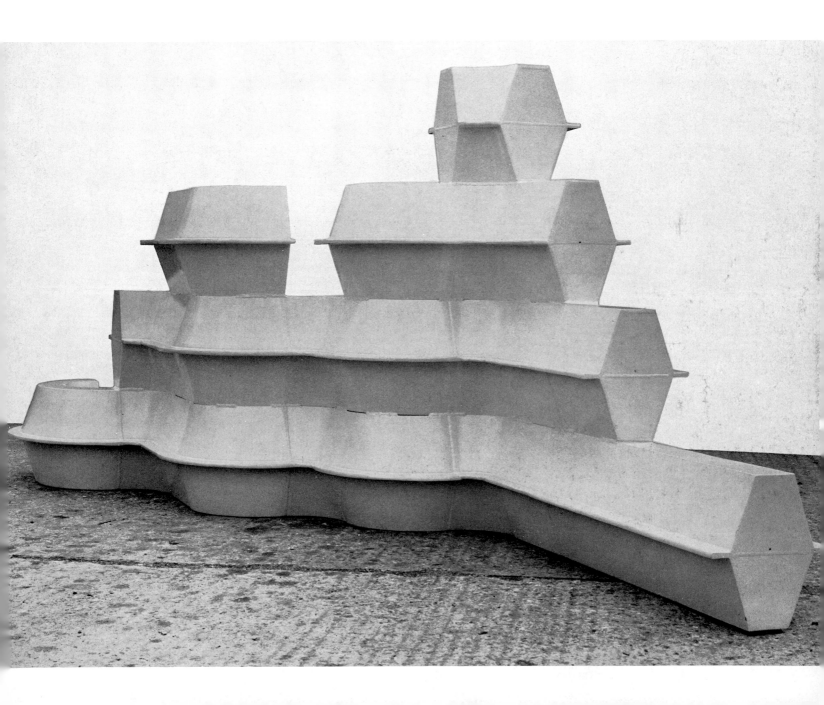

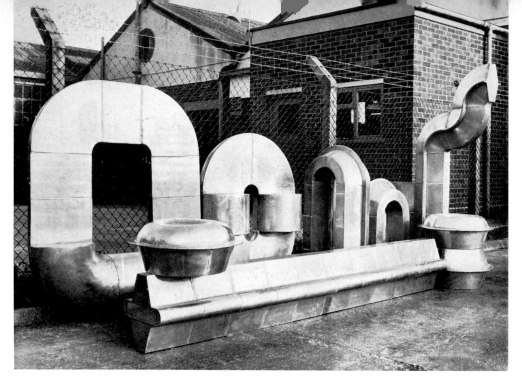

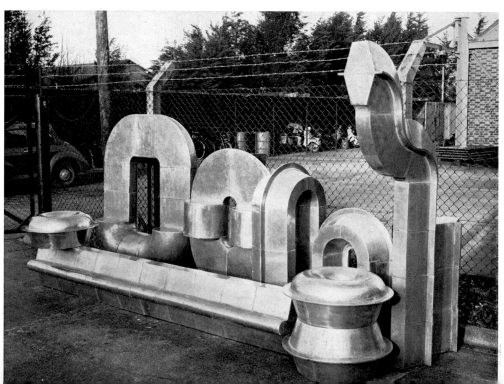

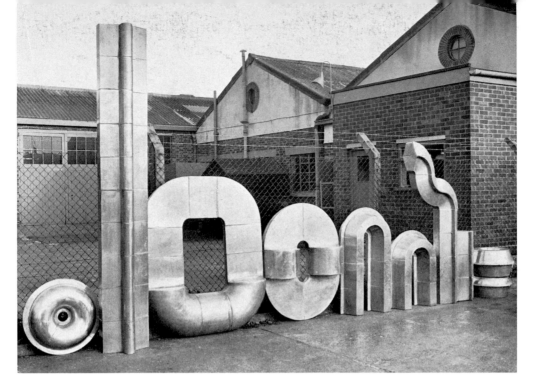

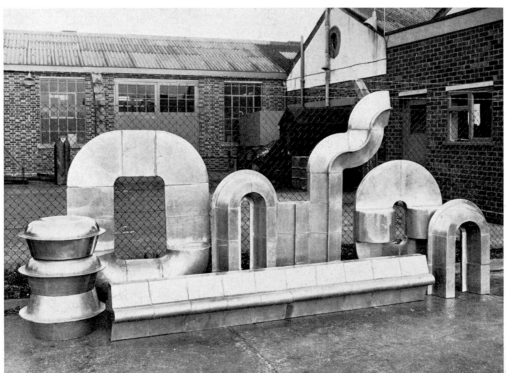

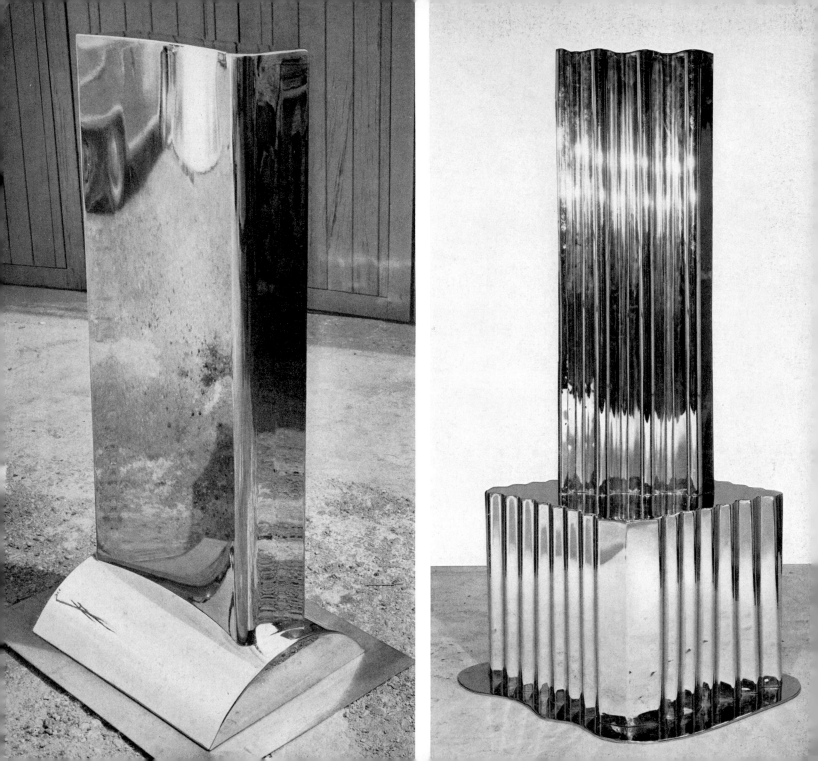

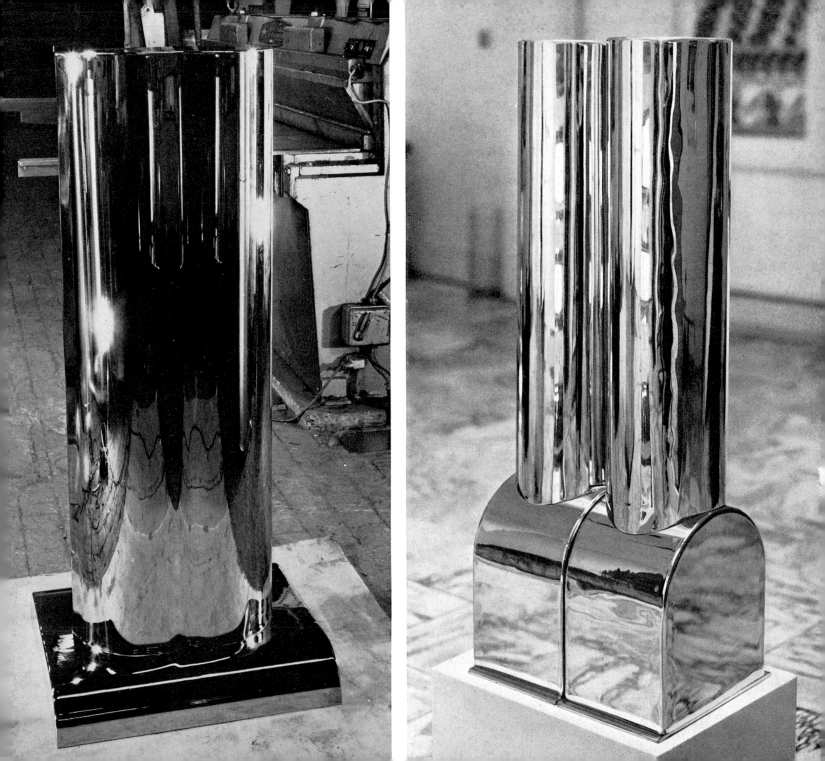

List of Plates

49 Hermaphroditical Idol, 1962 (right)
bronze, height 72″. Museum of Contemporary Art, São Paulo

50 Mekanik's Bench, 1963
Aluminium, height 71″. Pace Gallery, New York

51 Towards a New Laocoon, 1963
Aluminium, height 78$^1/_2$″. Hanover Gallery, London

52/53 Crash, 1964
Aluminium, height 96$^1/_2$″. Ulster Museum, Belfast

55 Rio, 1965
Bronze, 6 parts, height 71″. Mrs. Gabrielle Keiller, Kingston Hill

56 Medea, 1964
Aluminium, height 81$^1/_4$″. Rijksmuseum Kröller-Müller, Otterlo

57 Poem for Trio MRT, 1964
Aluminium, height 85$^1/_4$″. Fred Mueller, New York

58 Rizla, 1965
Polished aluminium, height 64″. The Tate Gallery, London

59 Marok-Marok-Miosa, 1965
Polished aluminium, height 39$^1/_2$″. Pace Gallery, New York

60 Neo-Saxeiraz, 1966
Polished aluminium, length 136″. Stedelijk Museum, Amsterdam

61 Etze, 1967
Polished aluminium, length 111″. Hanover Gallery, London

62 Mainspar, 1967
Painted aluminium, length 124$^1/_2$″. Hanover Gallery, London

63 Pan Am, 1966
Painted aluminium, length 131$^1/_2$″. Hanover Gallery, London

64/65 Domino, 1967/68
Polished aluminium, 9 pieces of various sizes. Hanover Gallery, London

66 Bhalk, 1967 (left)
Chrome-plated steel, height 51$^1/_4$″. Hanover Gallery, London

66 Sumen-Suren, 1965/66 (right)
Chrome-plated steel, height 60$^1/_2$″. Hanover Gallery, London

67 Fepho, 1967 (left)
Chrome-plated steel, height 45″. Hanover Gallery, London

67 Twefx, 1967 (right)
Chrome-plated steel, height 35″. Hanover Gallery, London

Biographical Data Exhibitions

1924	Born in Edinburgh, the son of Italian parents
1943	Studied at the Edinburgh College of Art
1944–47	Studied at the Slade School of Fine Art, London
1947–49	Stay in Paris; encounter with Constantin Brancusi, Tristan Tzara, Alberto Giacometti and Jean Dubuffet
1949–55	Taught textile design at the Central School of Art and Design, London
1953	British Critics Prize
1955–58	Taught Sculpture at St. Martin's School of Art, London
1956	Noma and William Copley Foundation Award
1960	David E. Bright Foundation Award "for the best sculptor under 45"
1961	Watson F. Blair Prize at the 64th Annual American Exhibition, Chicago
1960–62	Visiting Professor at Hochschule für bildende Künste, Hamburg
1967	First prize for sculpture at the Carnegie International Exhibition of Contemporary Painting and Sculpture, Pittsburgh
1968	Visiting Lecturer at University of California, Berkeley
since 1968	Lecturer at the ceramics department of the Royal College of Art, London

One-Man Exhibitions

1947	Mayor Gallery, London
1948	Mayor Gallery, London
1949	Mayor Gallery, London
1958	Hanover Gallery, London
1960	Betty Parsons Gallery, New York
	Manchester City Art Gallery
1962	Betty Parsons Gallery, New York
1963	Waddington Galleries, London
1964	Robert Fraser Gallery, London
	Museum of Modern Art, New York
1965	Gallery of the University of Newcastle-upon-Tyne
	Pace Gallery, New York
	Chelsea School of Art, London
1966	Scottish National Gallery of Art, Edinburgh
	Pace Gallery, New York
	Robert Fraser Gallery, London
1967	Hanover Gallery, London
	Rijksmuseum Kröller-Müller, Otterlo
	Pace Gallery, New York
1968	Galerie Neuendorf, Hamburg
	Stedelijk Museum, Amsterdam
	University of California, Berkeley
	Städtische Kunsthalle, Düsseldorf
1969	Württembergischer Kunstverein, Stuttgart
	Galerie Mikro, Berlin
1970	Pollock Gallery, Toronto

Principal Group Exhibitions

1952 26th Venice Biennale, British Pavilion: *Recent Sculpture*
1956 Whitechapel Gallery, London: *This is Tomorrow*
1957 4th São Paulo Biennial: *Ten Young British Sculptors*
1958 Stichting Sonsbeek, Arnhem
1959 Middelheim Park, Antwerp
 Documenta II, Kassel
 Museum of Modern Art, New York: *New Images of Man*
1960 30th Venice Biennale, British Pavilion
 2nd International Biennial Exhibition of Prints, National
 Museum of Modern Art, Tokyo
 Battersea Park, London
1960–61 Travelling exhibition of works from the Venice Biennale,
 tour of USA: *Sculpture Today*
1961 Musée Rodin, Paris
 Carnegie Institute, Pittsburgh
1962 Travelling exhibition, tour of USA: *British Art Today*
 3rd International Biennial Exhibition of Prints, National
 Museum of Modern Art, Tokyo
1963 7th International Art Exhibition, British Section, Tokyo
 Battersea Park, London
 7th São Paulo Biennial
1964 Documenta II, Kassel
 Arts Council Gallery, Belfast: *New Image*
 4th International Biennial Exhibition of Prints, National
 Museum of Modern Art, Tokyo
 Akademie der Künste, Berlin: *Neue Realisten und Pop Art*

1965 Editions Alecto, London: *Graphics in the Sixties*
1966 Galerie Der Spiegel, Cologne: *Englische Graphik*
 Battersea Park, London
 Stichting Sonsbeek, Arnhem: *5e Internationale beelden-
 tentoonsbelding*
 Museum Boymans-van Beuningen, Rotterdam: *Nieuwe
 Stromingen in de Britse Grafiek*
 Premier Biennial Exhibition, Cracow
1967 Solomon R. Guggenheim Museum, New York (there-
 after in Toronto, Ottawa, Montreal): *Sculpture from
 Twenty Nations, Guggenheim International Exhibition*
 Camden Arts Centre, London: *Trans-Atlantic Graphics
 '60–'61*
1968 Fondations Maeght, Saint-Paul: *L'art vivant 1965–1968*
 Kunstverein, Hamburg: *Britische Kunst heute*
 Documenta IV, Kassel
1969 Hayward Gallery, London: *Pop Art Redefined*
 Wallraf-Richartz-Museum, Cologne: *Kunst der sechziger
 Jahre: Sammlung Ludwig*
1970 Expo Osaka
 Rheinisches Landesmuseum, Bonn: *Pop Sammlung Beck*

Select Bibliography

Publications by Eduardo Paolozzi

1958

"Metamorphosis of Rubbish – Mr. Paolozzi explains his Process,"
The Times (London), May 2, 1958
"Notes from a Lecture at the Institute of Contemporary Arts,"
Uppercase (London), no. 1, 1958

1959

Statement in the exhibition catalogue *New Images of Man,*
New York, Museum of Modern Art, 1959

1960

"Mein Diktionär," *blätter + bilder* (Würzburg), no. 7, March/
April, 1960
"The Sculptor Speaks – the Enchanted Forest," *The Observer*
(London), April 24, 1960
Metafisikal Translations, London, 1960

1962

The History of Nothing, film

1963

The Metallization of a Dream. With a commentary by Lawrence
Alloway. London, Lion and Unicorn Press, 1963

1965

*As Is When – A series of screenprints based on the life and wri-
tings of Ludwig Wittgenstein.* London, Editions Alecto, 1965

1966

Kex, New York, William and Noma Copley Foundation, 1966
"Wild Track for Ludwig – The Kakafon kakkoon laka oon Elektrik
lafs," in *Eduardo Paolozzi – A Selection of Works from 1963–1966,*
London: Robert Fraser Gallery, Editions Alecto; New York: Pace
Gallery, 1966

1967

Moonstrips Empire News. 100 screenprints of images and text. With
an introduction by Christopher Finch. London, Editions Alecto, 1967
Universal Electronic Vacuum. A portfolio of ten screenprints.
London, 1967
"Theorieën over aesthetische mogelijkheden en het neo-plasticis-
me," in the exhibition catalogue *Eduardo Paolozzi,* Otterlo,
Rijksmuseum Kröller-Müller, 1967; in English: Exhibition cata-
logue *Eduardo Paolozzi – Complete Graphics,* Berlin, Galerie
Mikro, 1969
"Moonstrips–General Dynamic F.U.N.," *Ambit 33* (London), 1967

1968

"Analysis of Domains or the Spectrum of Alternatives," in the
exhibition catalogue *Eduardo Paolozzi – Plastik und Graphik,*
Düsseldorf, Städtische Kunsthalle, 1968
General Dynamic F. U. N., London, Editions Alecto, 1968

1969

"Why we are in Vietnam," *Ambit 40* (London), 1969

1970

"Moonstrips" in *Neue englische Prosa*, (ed.) Rolf-Eckart John, Cologne, 1970
Zero Energy Experimental Pile. Portfolio of six images in mixed printing techniques. London, 1970
Abba–Zaba, London, Hansjörg Mayer, 1970

Publications about Eduardo Paolozzi

1947

Robert Melville, "Eduardo Paolozzi," *Horizon* (London), September, 1947

1953

Michael Middleton, "Huit Sculpteurs britanniques," *Art d'Aujourd'hui* (Paris), vol. 4, no. 2, March, 1953

1955

Reyner Banham, "The New Brutalism," *Architectural Review* (London), vol. 118, no. 708, December, 1955

1956

Lawrence Alloway, "Eduardo Paolozzi," *Architectural Design* (London), April, 1956
J. P. Hodin, "Eduardo Paolozzi," *Quadrum* (Brussels), May, 1956

1958

"The Romantic Trend in Modern Sculpture," *The Times* (London), December 5, 1958

1959

Robert Melville, "Eduardo Paolozzi," *Motif* (London), no. 2, February, 1959
Robert Melville, "Exhibitions," *Architectural Review* (London), vol. 125, no. 746, March, 1959
Edouard Roditi, "Interview with Eduardo Paolozzi," *Arts* (New York), vol. 33, no. 8, May, 1959

1960

Friedrich Bayl, "Paolozzi, der Ketzer," *blätter + bilder* (Würzburg), no. 7, March/April, 1960
Robert Melville, "Eduardo Paolozzi," *L'Oeil* (Paris), no. 65, 1960
Lawrence Alloway, "Paolozzi and the Comedy of Waste," *Cimaise* (Paris), vol. 7, no. 4, October/December, 1960
Edouard Roditi, "Eduardo Paolozzi," *Dialogues on art*. London, Secker & Warburg, 1960

1961

Reyner Banham, "History of Immediate Future," *The Listener* (London), February 23, 1961

1962

Dore Ashton, "Art," *Arts and Architecture* (Los Angeles), vol. 79, no. 6, June, 1962
Rolf-Gunter Dienst, "Eduardo Paolozzi," *Das Kunstwerk* (Baden-Baden), vol. 14, no. 16, October, 1962

1963

Jasia Reichardt, "Eduardo Paolozzi," *The London Magazine*, vol. 2 no. 12, March, 1963
Michael Middleton, *Eduardo Paolozzi*, London, Methuen, 1963
Jasia Reichardt, "Paolozzi and what led up to a Certain Event in 2.000 A.D.," *Metro* (Milan), 8, 1963

1964

Jasia Reichardt, "The Revival of Machine Esthetic," *Architectural Design* (London), October, 1964
Jasia Reichardt, "Eduardo Paolozzi," *Studio international* (London), 168/858, 1964

1965

Jürgen Claus, *Kunst heute*, Hamburg, 1965
Rolf-Gunter Dienst, *Pop-Art*, Wiesbaden, 1965

1966

Eduardo Paolozzi – A Selection of Works from 1963–1966, London, Robert Fraser Gallery and Editons Alecto, and New York, Pace Gallery, 1966
Christopher Finch, "Paolozzi in the Sixties," *Art International* (Lugano), vol. 10, no. 9, November, 1966

1967

P. H. Hefting, "Twee in een, Paolozzi en Caro in het museum Kröller-Müller," *Museum Journal*, series 12, no. 2, 1967
Uwe M. Schneede, "Eduardo Paolozzi," *Das Kunstwerk* (Baden-Baden), vol. 20, nos. 11–12, 1967

1969

Diana Kirkpatrick, *Eduardo Paolozzi – A Study of his Work 1946–1968*, Dissertation, University of Michigan, Ann Arbor, 1969
Christopher Finch, *Image as Language. Aspects of British Art 1950–1968*, London, Penguin, 1969
John Russell, Suzi Gablik, *Pop Art redefined*, London, Thames and Hudson, 1969

1970

George Melly, *Revolt into style. The pop arts in Britain*, London, 1970
Diana Kirkpatrick, *Eduardo Paolozzi*, London, 1970